IMAGES
of America
CAPE ANN
GRANITE

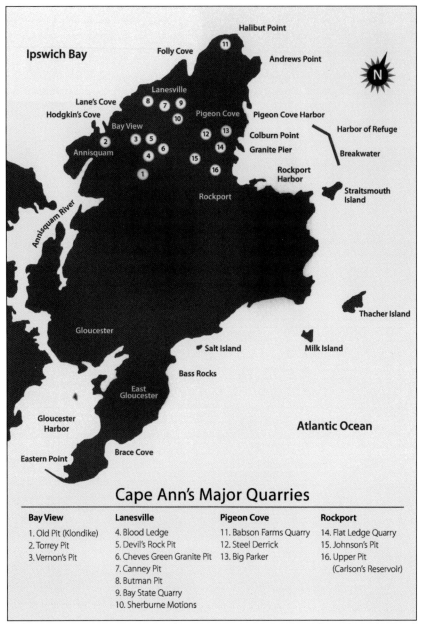

Cape Ann's Major Quarries

Bay View	Lanesville	Pigeon Cove	Rockport
1. Old Pit (Klondike)	4. Blood Ledge	11. Babson Farms Quarry	14. Flat Ledge Quarry
2. Torrey Pit	5. Devil's Rock Pit	12. Steel Derrick	15. Johnson's Pit
3. Vernon's Pit	6. Cheves Green Granite Pit	13. Big Parker	16. Upper Pit
	7. Canney Pit		(Carlson's Reservoir)
	8. Butman Pit		
	9. Bay State Quarry		
	10. Sherburne Motions		

Although there were over 60 quarries and motions across Cape Ann from the 1830s to the 1950s, this map represents only the major quarries and quarrying areas that are noted in this book. (Author's collection.)

ON THE COVER: William R. Cheves, owner of the Cheves Green Granite Company, is holding a work order for his men. This is his Devil's Rock Quarry in Lanesville, which was sometimes known as Deep Pit and now Hancock Quarry, named after the famous sculptor Walker Hancock, who bought the property in the early 1930s. Cheves owned eight acres of land and two other quarries, Cheves and Cheves Reservoir Quarry, which were worked until 1917. (Courtesy of the Cape Ann Museum.)

IMAGES
of America

CAPE ANN
GRANITE

Paul St. Germain

ARCADIA
PUBLISHING

Copyright © 2015 by Paul St. Germain
ISBN 978-1-4671-2363-1

Published by Arcadia Publishing
Charleston, South Carolina

Printed in the United States of America

Library of Congress Control Number: 2014958700

For all general information, please contact Arcadia Publishing:
Telephone 843-853-2070
Fax 843-853-0044
E-mail sales@arcadiapublishing.com
For customer service and orders:
Toll-Free 1-888-313-2665

Visit us on the Internet at www.arcadiapublishing.com

*To my grandchildren, Taylor, Olivia, Hunter, Luke,
Nathaniel, Shane, and Vivienne, who are the foundation
blocks of our family, may you all build wonderful lives.*

CONTENTS

ACKNOWLEDGMENTS

I would like to extend my gratitude to the following individuals who gave generously of their time, shared their knowledge of granite and its story, provided their expertise in working with vintage photographs, and dispersed their wisdom. All of this support enhanced my research and understanding of the history of granite on Cape Ann.

Martha Oaks, curator of the Cape Ann Museum, encouraged me to write this book to complement the museum's excellent granite exhibit. This was prompted by the fact that the definitive book on Cape Ann granite by Barbara Erkkila, *Hammers On Stone*, is long out of print. I thank her also for allowing me to use some of her words in a portion of my introduction.

My thanks to Barbara Erkkila, Cape Ann granite expert, who I spoke to many times before her death in 2013. She was always eager to answer my many questions with generosity, grace, and humor. I will miss her.

Stephanie Buck, Cape Ann Museum librarian, guided me to the many files on Cape Ann and the Barbara Erkkila Collection.

Fred Buck, Cape Ann Museum photograph archivist and digital magician, repaired and digitized hundreds of photographs from 1830 to 1930, many from Barbara's collection.

Gwen Stephenson, curator of the Sandy Bay Historical Society, gave me access to the archives of the Rockport and Cape Ann Granite Companies, which dated back to the 1830s, providing me with a wealth of records, images, and correspondence.

Les Bartlett, Cape Ann historian and Granite Museum consultant, shared his extensive knowledge of the Rockport Granite Company and the quarry workers of the mid-19th century. Les assisted in the development of the granite exhibits at both the Cape Ann Museum and the Sandy Bay Historical Society Museum.

Lois Brynes, natural historian, actually lives near several quarries in Pigeon Cove. Lois taught me how granite got here and what it is and what it is not. Also, she tipped me to information sources I would never have found on my own.

Thanks to Caitrin Cunningham, my patient editor at Arcadia, who reviewed hundreds of photographs and selected the best quality possible for this book.

Most of the images appear courtesy of the Cape Ann Museum (CAM) and the Sandy Bay Historical Society (SBHS); all others are as noted.

INTRODUCTION

Granite is the land itself and has waited for the ingenuity and vision of man to give it beauty and meaning.

—The Building Stone Institute of America Pledge

The history of Cape Ann granite started 400 million years ago when the bedrock batholithic granite cooled deep under a volcanic micro-continent known among geologists as Avalonia. Avalonia is the name given by modern geologists to the first land forming the ground beneath our feet here on Cape Ann. A deep-seated igneous rock called granite makes up most of the bedrock of Cape Ann. Igneous rock (Greek *ingis*, meaning fire) is formed by the cooling and crystallization of molten rock material called magma when deep underground. The harvesting of granite from quarries dug deep in the earth was big business here on Cape Ann from the 1830s through the early 20th century. Second only to fishing in economic output, for 100 years the granite trade played a pivotal role in the local economy, providing jobs for many, turning profits for some, and generating tons and tons of cut granite that was used here on Cape Ann and shipped to ports all along the Atlantic Seaboard and eventually across the nation.

Granite quarrying started slowly in the area in the late 18th century, with small operators peppered across rocky terrain. Construction of a fort at Castle Island in Boston Harbor in 1798 followed by a jail in nearby Salem in 1813 jump-started the local granite business. During the 1830s and 1840s, the trade grew steadily. By the 1850s, the stone business was firmly established, and Cape Ann granite was known throughout the region. So extensive and so awe inspiring were operations during the second half of the 19th century that some observers feared that the business might actually run out of stone.

While granite was taken from the earth in all different sizes and shapes, Cape Ann specialized in the conversion of that granite into paving blocks, which were used to finish roads and streets. Millions of paving stones were shipped out of Cape Ann annually, destined for construction projects in New York, Philadelphia, Pennsylvania, New Orleans, Louisiana, and San Francisco, California. The cutting of paving stones kept Gloucester and Rockport workers busy throughout the year but particularly during the winter months. (It was said that granite was more difficult to wrestle out of the earth during winter, hence the cutting of paving blocks out of larger pieces of stone was something that kept men employed during the cold months.) Come summer, large shipments of blocks would be packed aboard specially designed sloops and transported to distant ports.

The quarries of Cape Ann were numerous; at least 60 were worked from the mid-1800s until 1930, when the Rockport Granite Company went out of business. This book is organized to take readers on a tour of the major quarries around Cape Ann, starting on the western shore in the Bay View section of Annisquam and Hodgkins Cove. Next, we move on to Lanesville, Lane's Cove, Folly Cove, around to the northern end of the cape past Halibut Point's Babson Farms Quarry

heading south down to Pigeon Cove, and finally to Rockport, the home of the Rockport Granite Company, which had purchased most of the quarries and granite companies by 1915.

The granite companies consisted of two-man motions as well as large ones employing from 800 to 1,200 workers over the years. A motion was a small quarry that usually was operated by two men who cut paving stones to sell themselves or to the big quarry companies. The majority of workers were immigrants who came from Ireland, Finland, Sweden, Scotland, and Italy. The major companies included the Rockport Granite Company (1864–1931), Cape Ann Granite Company (1869–1892) out of Bay View, Cheves Green Granite Company (1876–1917), Lanesville Granite Company (1855–1909), Pigeon Hill Granite Company (1870–1914), and Bay State Granite Company (1874–1879). All the companies had limited life spans, some began as early as 1848, and few lasted until 1948, when the last company, the Ultimate Paving Block Company (1930–1948), finally went under.

Companies had significant investments in equipment; a few even built their own railroads. Some had as many as 40 derricks, employing air- and steam-driven hoisting engines, drills, and pumps; pneumatic tools, surfacing machines, polishing lathes, and pendulum polishers; and their own fleet of granite-carrying vessels, including sloops, schooners, barges, towboats, and lighters; and oxen, horses, and wagons to move granite and haul freight.

The granite they produced was used as foundation stones, bridges, monuments, paving blocks, seawalls, dry docks, churches, bank buildings, memorials, curbing, and crushed stone. Cape Ann granite was known to be the hardest, as it was made up of hornblende, discussed in a sales flyer on the Rockport Granite Company as "resembling in composition the Egyptian granite of which ancient obelisks and sarcophagi were built." It came in a variety of colors from shades of gray and sea green to Moose-A-Bec red. Due to its hardness and texture it could be offered in hammered finishes, and by virtue of the material's density and grain it was able to be highly polished.

My book will introduce you to the quarries, the companies, the people, and how the world-famous Cape Ann Granite was employed. I hope you enjoy it.

One

BAY VIEW QUARRIES

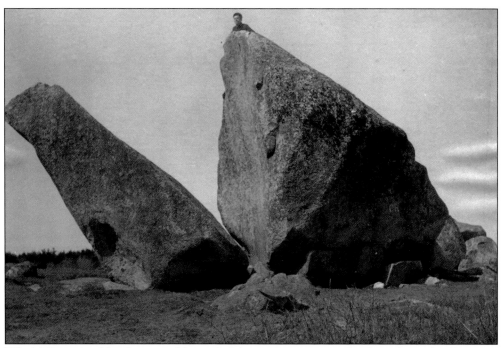

Whale's Jaw, a boulder that resembles a whale's mouth opening to the sky, is located in Dogtown on Cape Ann. This rugged terrain is a product of the late Pleistocene epoch when glaciers, some a mile thick, spilled gigantic rocks (glacial till or erratics) across New England. This boulder is a representative part of the vast moraine of Cape Ann that houses enormous amounts of bedrock granite. (SBHS.)

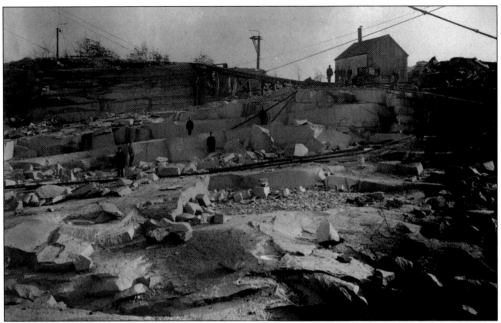

The Bay View area of Gloucester had at least seven quarries: Hood, Torrey Pit, Klondike Reservoir (Old Pit), Cow Pit, Vernon's Pit, and Nelson's Pit. William Torrey owned the first quarry in Bay View. Most of these operations delivered their granite to Hodgkins Cove, where, in the 1850s, Beniah Colburn built the original granite wharf and cutting sheds where granite was finished and shipped. (CAM.)

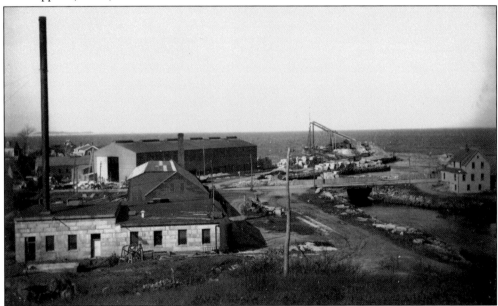

This is the view of the Bay View stone yard at Hodgkins Cove about 1910. It shows the Cape Ann Granite Company's power plant, cutting shed, polishing mill, and the dock from which paving stones and dimensional granite was shipped. The 150-foot-long mill contained polishing machines, a surfacing machine, a gang saw, and a large lathe. The cutting shed behind that was 240 feet long by 65 feet wide. (CAM.)

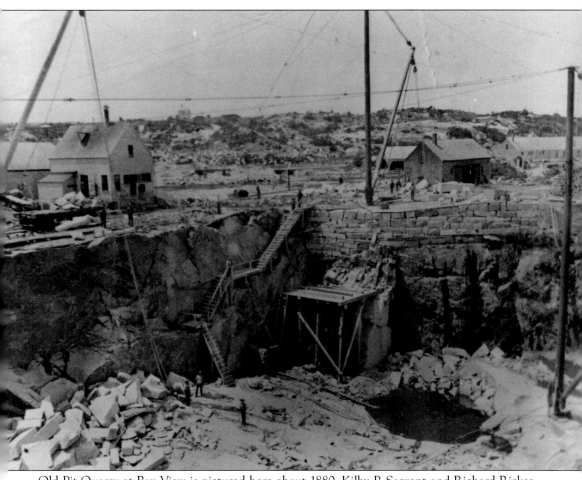

Old Pit Quarry at Bay View is pictured here about 1880. Kilby P. Sargent and Richard Ricker opened this quarry as a two man motion in 1846. As it got deeper and bigger, it became known as Deep Pit and eventually Old Pit. It was famous for its medium-gray granite. This granite was quarried here for both the Boston and Baltimore Post Offices as well as for the Longfellow Bridge in Cambridge, Massachusetts, which spans the Charles River, and the Brooklyn Bridge in New York. Note the railed stairway down to the bottom of the pit. Three derricks are used here. The dark spot in the lower right is water that accumulates and has to be pumped out on a daily basis by hand. This was before the invention of steam pumps used in most quarries. Now this old quarry is a water supply for the City of Gloucester and called Klondike Reservoir. (SBHS.)

Col. Jonas Harrod French organized and became president of the Cape Ann Granite Company in 1869 and partnered with his former commander Gen. Benjamin F. Butler. Colonel French was a director of a bank that failed in 1891 and was indicted for embezzlement. French's Cape Ann Granite Company went into receivership against his liabilities of $900,000, and ownership passed to the Rockport Granite Company in 1893. (CAM.)

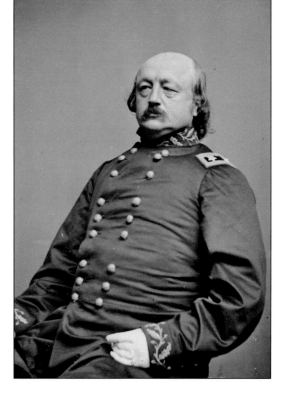

Butler was a soldier, lawyer, politician, and the 33rd governor of Massachusetts, elected in 1883. He was elected to the US House of Representatives for three terms from 1867 to 1879. He also ran for president in 1884 with the Greenback Party. Butler was a savvy politician but not a great military man. Although a favorite of Abraham Lincoln, who made him a major general, his failures in battle cost him his military career. (Author's collection.)

This map plots the location of Hodgkins Cove, which was the shipping point for all granite dug from the Bay View quarries. Butler's home as well as that of his partner Col. Jonas H. French are indicated on the map. Together they created the Cape Ann Granite Company in 1867. (SBHS.)

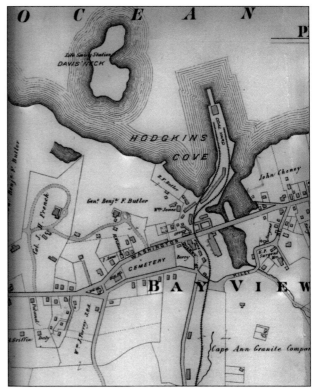

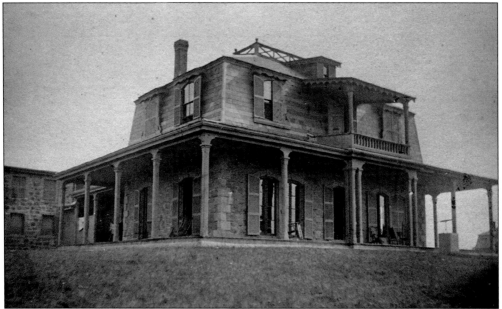

Pictured here in 1880 is General Butler's granite summer home, the Homestead, which stood on a 47-acre estate in the Bay View section of Gloucester. Colonel French's estate Rocklawn abutted Butler's and was also built of Cape Ann granite from their company's quarry. It was Butler who named the area Bay View, as his estate looked down onto a magnificent view of Ipswich Bay. (CAM.)

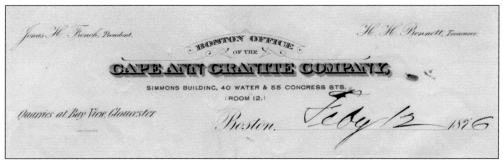

This is the letterhead of the Cape Ann Granite Company, dated 1870; the company was led by Col. Jonas H. French. When the company was sold in May 1893, a catalog of property was issued for the auction. Besides 188 acres of land in Bay View and Maine, it also listed the barge *West End*, the sloop *Albert Baldwin*, one locomotive, a yoke of oxen, and thousands of quarry tools, among other equipment. (SBHS.)

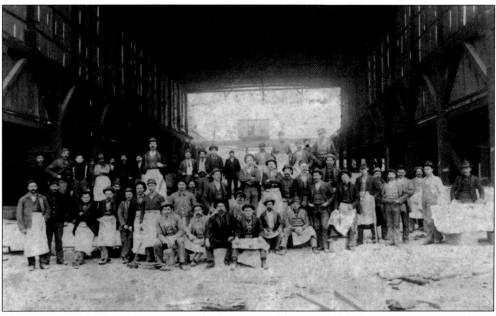

The crew from the Bay View cutting shed is pictured here in 1895. Quarrymen were made up of Irish, Scots, Italians, Swedes, and Finns. The Finns and Swedes were the last group to come to Cape Ann, in the 1870s. The major granite companies owned large blocks of tenements in Rockport and Bay View, which housed these workers. Many families in the area took in boarders as well. (SBHS.)

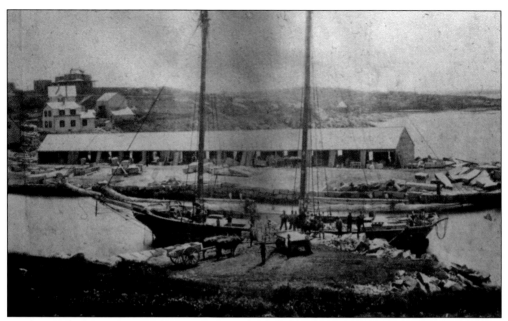

Workers at the Cape Ann Granite Company's Bay View stone yard in Hodgkins Cove are loading paving stones just delivered by oxen aboard a granite sloop in 1869. The individual cutting sheds are in the background, where men cut paving stones. High up on the hill to the left is Gen. Benjamin Butler's home. In 1874, the company shipped 5.5 million pavers for the streets of Boston. (SBHS.)

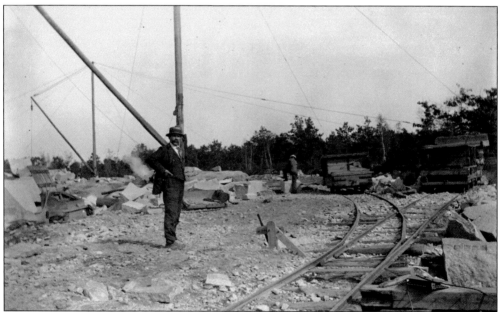

William R. Cheves stands at the junction of his railroad track, one spur leading to Blood Ledge, the other ending at his other quarries. The Cape Ann Granite Company built a half-mile railway from Hodgkins Cove up to Old Pit (Klondike) and around to Blood Ledge. It used a locomotive called *Polyphemus*, named for one of the cyclops in Greek mythology because of its bright single headlight. (CAM.)

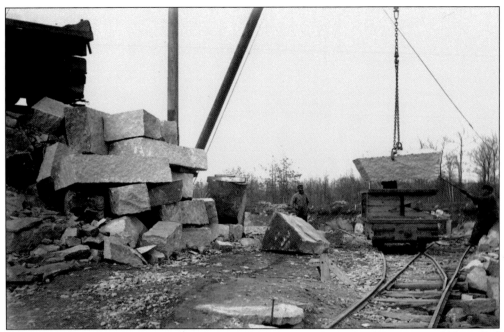

This is one of many railcars owned by the Cape Ann Granite Company. This car would be pulled by the locomotive *Polyphemus* through the stone yards to Hodgkins Cove wharf and its cargo of stone loaded onto granite schooners and sloops. On September 16, 1870, the local newspaper announced that the company had just completed a new railroad, and engine and rolling stock had been received. (CAM.)

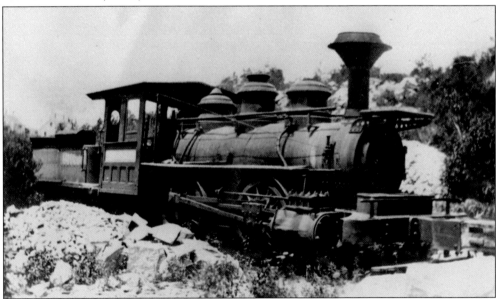

Colonel French purchased his second engine, the 20-ton locomotive *Polyphemus No. 2*, in 1879. The engine was built by Hinkley Locomotive Works in Boston; began operations on Thursday, March 6, 1879; and continued in use until 1930. It was brought to the pier at Hodgkins Cove by the barge *Plain Jane*, which towed the engine from Boston by tugboat. The engine and tender together measured 30 feet long. (CAM.)

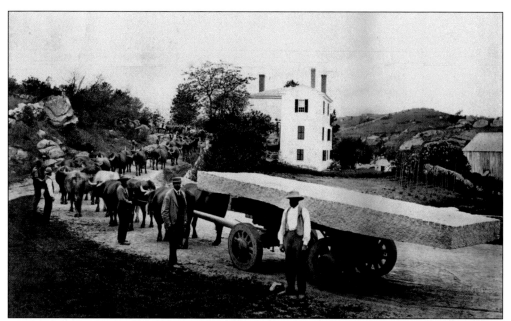

In 1870, the Cape Ann Granite Company shipped the largest piece of granite they had ever moved up to that time. It was a rough-cut step for the First Baptist Church in Gloucester drawn by 15 yoke of oxen with a driver for each. The 18-foot stone, seven feet wide and a foot thick, traveled seven miles to Gloucester. Colonel French is second from the right helping guide the load. (CAM.)

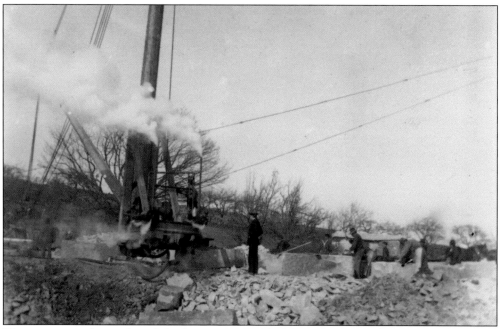

This is a steam-driven derrick loading granite in Hodgkins Cove near the Cape Ann Granite Company's blacksmith shop on March 10, 1894. In the 1840s, granite was cut by hand drills and hammers, but around 1860, pneumatic air drills were introduced, making stonecutting much easier. Steam-powered machinery came into use in the 1880s. (SBHS.)

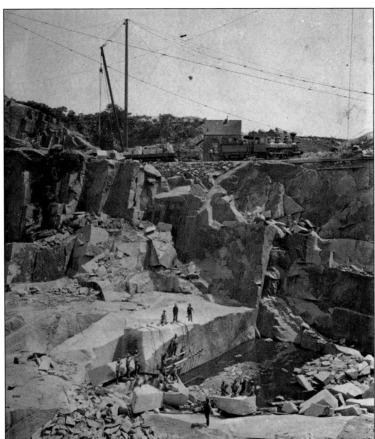

This is the 200-foot-deep Old Pit Quarry in Bay View as it appeared around 1885. Workers line the various levels while *Polyphemus No.2* prepares to hitch a railcar of stone on the rim of the quarry. On June 27, 1871, seven kegs of powder were used to cut the largest block of granite ever from the quarry. It measured 122 feet long, 45 feet wide, and 30 feet deep and weighed 14,000 tons. (CAM.)

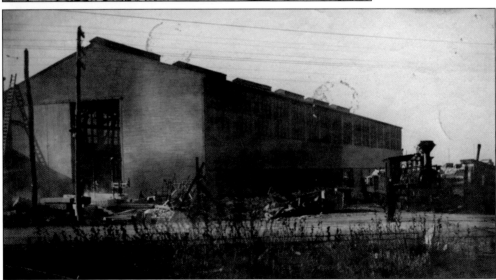

The locomotive *Polyphemus No.2* is backing up to the Hodgkins Cove wharf to deliver stone, passing by the 240-foot-long Bay View cutting shed. This shed is no longer there, but the property and the building that replaced it is now owned by the University of Massachusetts and used as a marine research center. (CAM.)

Two

LANESVILLE QUARRIES

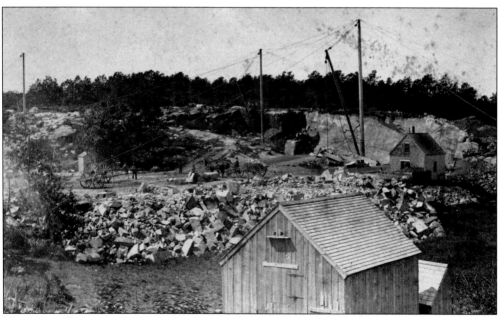

The Lanesville area had at least 16 quarries and many small motions. The quarries included Devil's Rock, Blood Ledge, Breakwater, Nickerson Pit, Barker Company, Cheves Pit, Cheves Reservoir, Valley Pit, Long Pit, Canney's Pit, Fitzgibbon Quarry, Bay State Quarry (seen here), Butman Pit, Sherburne Motions, Barker Reservoir, and Pine Pit. (SBHS.)

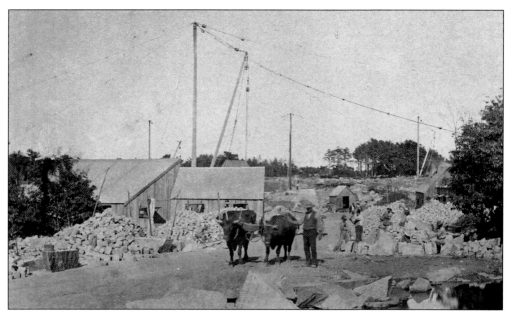

Bay State Granite Company's quarry was first started by two Pigeon Cove residents, James Edmunds and Gustavus Lane Jr., before the Civil War. They kept 50 oxen in small barns near two quarries, Bay State and Pine Pit. The oxen not only pulled the wagons, but also were used to power the hoists used to lift the granite blocks from the ledge. (SBHS.)

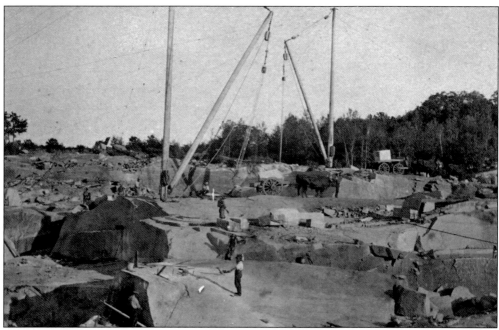

Charles Guidet took over as president of Bay State in 1874. When Bay State folded in 1879, Guidet was the principal bidder and took over the company. In September 1892, Guidet died, and the company went out of business. It was bought by Col. Jonas H. French, who had earlier failed with the Cape Ann Granite Company. By February 5, 1894, French had renamed it for his previous company, the Cape Ann Granite Company, and laid plans for a new quarry railroad. (SBHS.)

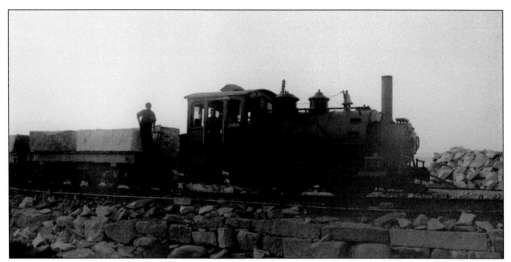

The famous *Nella*, a 0-4-0 tank-type locomotive made at the Rhode Island Works, was introduced by the Cape Ann Granite Railroad. A 1.5-mile-long quarry railroad connecting Lanesville quarries with Pigeon Cove Harbor was built by Colonel French in 1895. In 1910, the *Nella* was sold by Cape Ann Granite Company for $3,000; she went on to be used at Blood Ledge Quarry with *Polyphemus* until the late 1920s. (SBHS.)

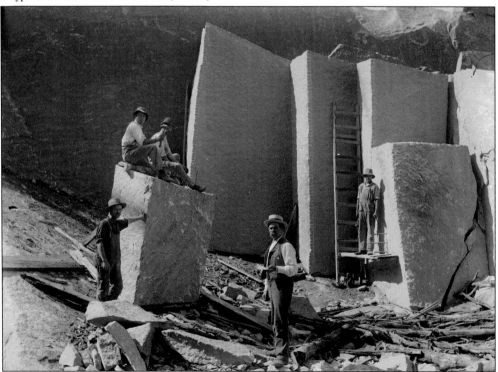

William Robb Cheves, who owned the Lanesville Cheves Green Granite Company, is pictured here holding a work order for his men in 1876. Cheves came to Lanesville in 1872 from Scotland as a paving cutter, and he operated his first quarry at Devil's Rock under the name Cheves Green Granite Company, adding the Cheves Pit Quarry later. Cheves's father had quarried stones for Balmoral Castle in Scotland. (CAM.)

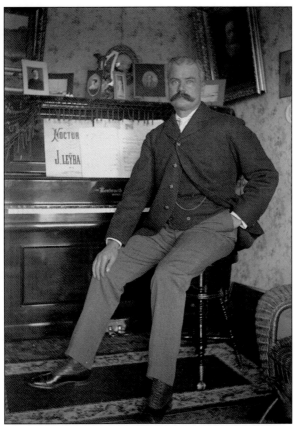

William Robb Cheves is at home by his piano at 31 High Street, Lanesville, around 1910. He was born in Aberdeen, Scotland, and died here in April 1920. His son Alexander was his bookkeeper, stationery engineer, and photographer. Many of the photographs of the Cheves operation were captured by his son, including this one. (CAM.)

William Robb Cheves's business card features the same photograph as the cover of this book. His card advertised, "Contractor for furnishing rough and hammered granite dealer in flagging, curbing and building stone with paving blocks as a specialty." (CAM.)

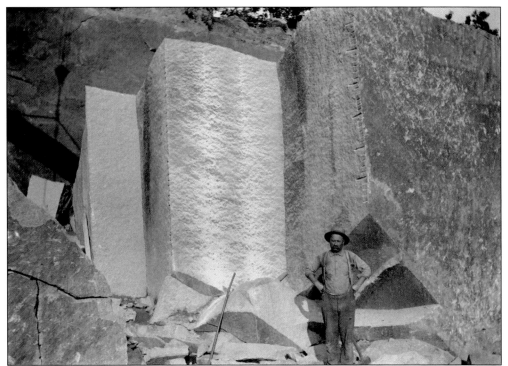

William R. Cheves stands next to a block of granite ready to be broken away from the ledge. The small plughole grooves in the stone above him mark the cutting edge of a recently removed block. Cheves was usually seen in his quarry wearing a wide-brimmed straw hat as protection from the sun. (CAM.)

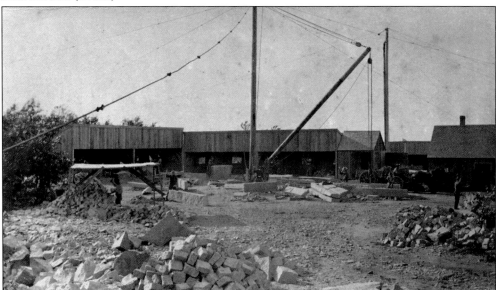

A motion was the quarryman's term for a small quarry. They were generally worked by two men who used drills and hammers to produce paving stones. The paving-stone cutters are in their bunkers, which are lined up behind the derrick at the Cheves Green Granite Company, Lanesville. There is one cutter on the left that has made his own canvas-covered area to shield the sun. (SBHS.)

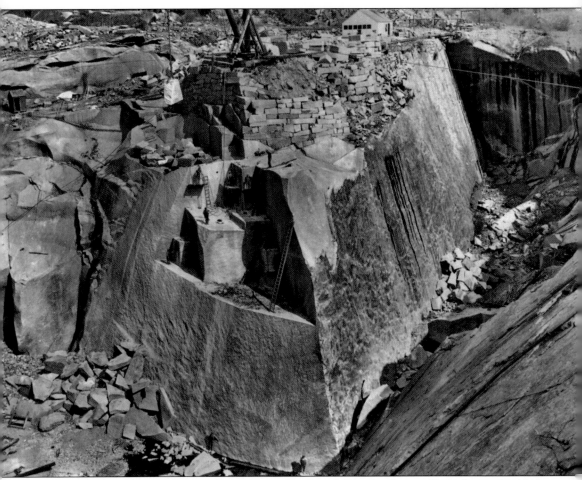

Blood Ledge Quarry in Lanesville was owned by Joseph Blood, who established it in the 1840s but lacked the money to develop it. Blood later became Colonel French's bookkeeper, and French bought the quarry from Blood's widow in 1868. It was a huge quarry, measuring almost a mile wide in an equilateral quadrangle shape. It was over 225 feet deep. The granite had few seams, almost no knots or imperfections, and massive slabs could be blasted free without shattering. The color of the granite was a pale green, and the operation included six derricks and four hoisting engines. A sample of the granite can be seen today as the base to the Joan of Arc statue in Gloucester's Legion Square. It was from this quarry that the giant 150-ton stone for the base of the monument to Gen. Winfield Scott in Washington, DC, was cut, the largest single piece ever quarried on Cape Ann. Along with other stones, the entire base weighed over 400 tons. The quarry was eventually bought by the Rockport Granite Company in 1909. (SBHS.)

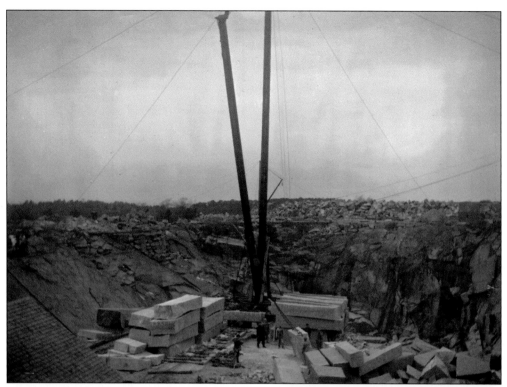

This photograph was taken on January 9, 1917, at Blood Ledge Quarry in Lanesville. There was an accident involving a worker by the name of Thomas Erwin on December 11, 1916, and officials are shown examining the scene. (SBHS.)

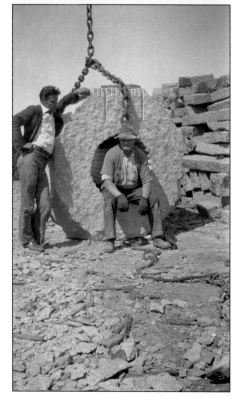

This one-ton piece of granite came out of the Fitzgibbon Quarry in Lanesville in 1933. It was to be used for the World War I Memorial Municipal Auditorium in Worcester, Massachusetts. Here is Harold Toneatti standing and looking at Carl Carlson, the owner, sitting in the ring. (CAM.)

A windmill was built by a Swedish motion operator near Lanes Cove, on the north side of Lanesville. It was used to pump out excess water from a pond on his site. A Finnish man by the name of Peltakorpi built a windmill to pump water from a pit for his bathhouse use on Saturdays. (CAM.)

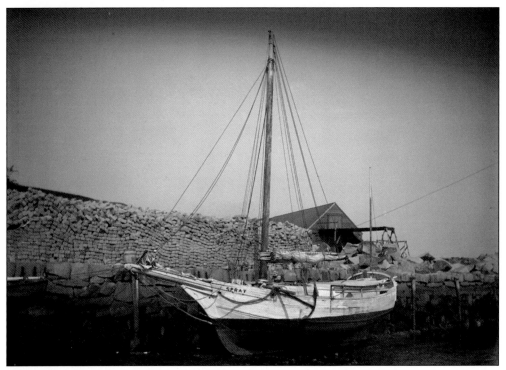

Joshua Slocum's 36-foot gaff-rigged oyster sloop *Spray* is tied up at the pier at Lanes Cove Granite Company at low tide. Note the paving stones stacked up on the pier. Slocum was the first man to single-handedly sail around the world between 1895 and 1898. His book, *Sailing Alone Around the World*, published in 1900, was an international bestseller. (CAM.)

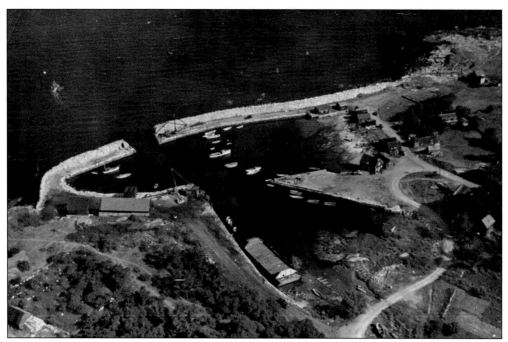

Lanes Cove Harbor, once called Flatstone Ledge, was the principal shipping point for all granite from the area. This aerial photograph from about 1960 shows two derricks near the entrance and an old barge. Note the 52-foot gap used to enter the harbor; at one time, there was a line of fish shacks and cutting sheds on the north side. In 1843, Jotham Taylor built the breakwater using stone from Butman's Pit. (CAM.)

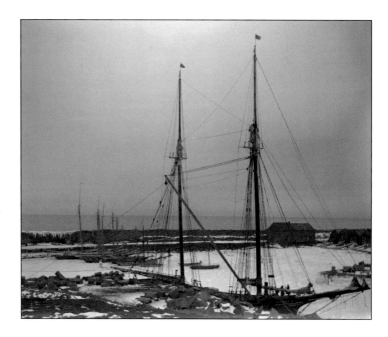

The schooner *Multnomah* is frozen in Lanes Cove Harbor in 1898. Built in 1889 in Ledyard, Connecticut, it was 124 gross tons and 82 feet long. The schooner was owned by the Lanesville Granite Company and carried granite for its owner, William R. Cheves, who also owned the Green Granite Company. (CAM.)

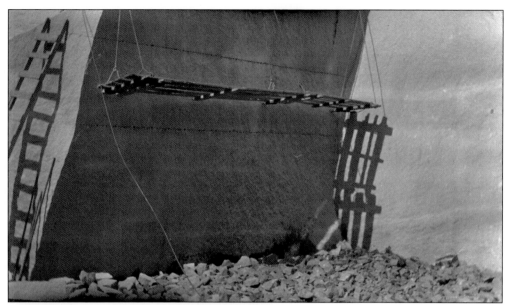

This granite ledge at the Fitzgibbon Quarry in Lanesville clearly shows the line of drill holes that mark the next lift of granite that will be loosened from the ledge. The scaffold was used by the drillers to stand on two levels while they drilled the holes. (CAM.)

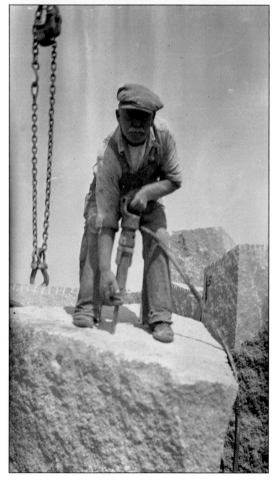

Jacob Soltti, a Finnish quarryman at Fitzgibbon Quarry, is working with a plug drill about 1902. After a large block was separated from the main mass, it was cut on site into the approximate shape and size needed. A chalk line was snapped on the block to mark it off, and then holes were drilled along it with a plug drill. (CAM.)

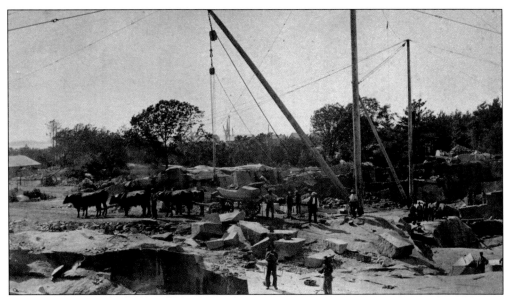

Oxen were the mainstay muscle power for hauling granite until the railways were established. This yoke of oxen is heading to Lanes Cove wharf. Blanchard Mitchell drove oxen in 1890, and he would run back and forth, urging the oxen on. It was said that Mitchell ran 10 miles for every one mile that the oxen covered. He became the engineer of the Bay State Quarry Railroad's locomotive *Nella*. (SBHS.)

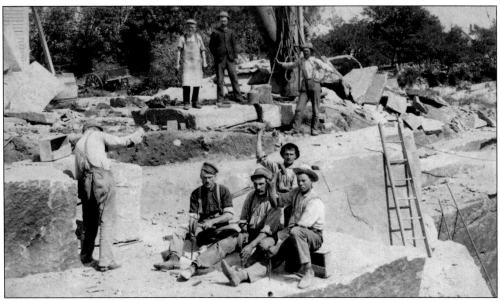

Around 1885, men demonstrate their hammers at Butman's Pit, now called Manship's Quarry. There were many types of hammers—bull set, striking, peen, bush, mash, paving cutter buster, side, cutter reel, and hand hammers. These men are using hand hammers with plug drill bits for making cutting holes to split the granite. Blacksmith Joe McLellan, with apron, stands behind the group. (CAM.)

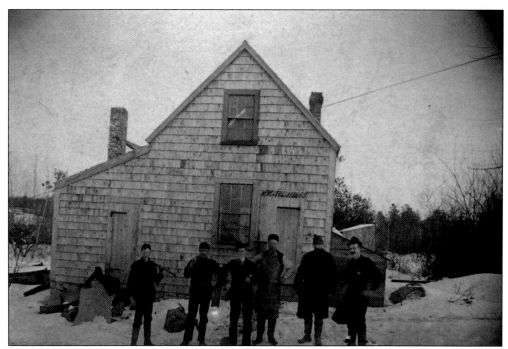

Six quarrymen pose in front of the company office at Cheves Quarry in wintertime. From left to right are Pat Coursey, John Nyhan, Maurice Cleary, William Allen, Dan Roach, and Joe McLellan. Their last names attest to the wide diversity of nationalities who worked the quarries. (CAM.)

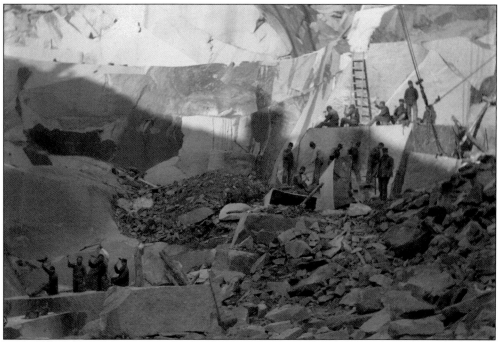

In three crews, 16 quarrymen on three levels are hammering plug drills in parallel lines to dislodge blocks. The man in the center is holding a metal square used to check each block for proper shape and measure. This is the quarry at Blood Ledge. (CAM.)

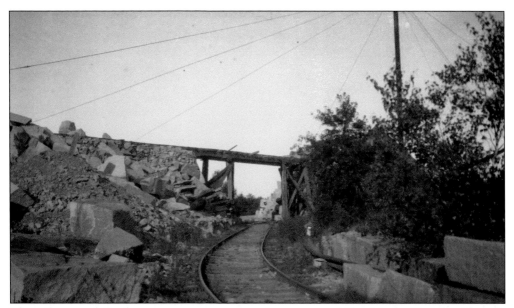

The railway track for the grout stone cars weaves its way around Blood Ledge Quarry and over a trestle. The trestle was built so that grout (unusable granite scraps) could be dumped and piled high at the end of the line, as seen on the left. (CAM.)

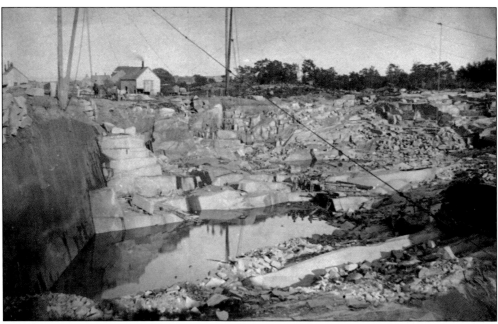

Manship's Quarry was named for internationally known sculptor Paul Manship (1885–1966), who had his home and a barn studio on the quarry rim. He bought 14 acres in 1943 to take advantage of the views for his work. Manship's best known work is *Prometheus Bringing Fire from Heaven* (1934), located in Rockefeller Center, New York City. Two of his works are on exhibit at the Cape Ann Museum, *Indian Hunter and his Dog* (1926) and *Shoebill Stork* (1932). (SBHS.)

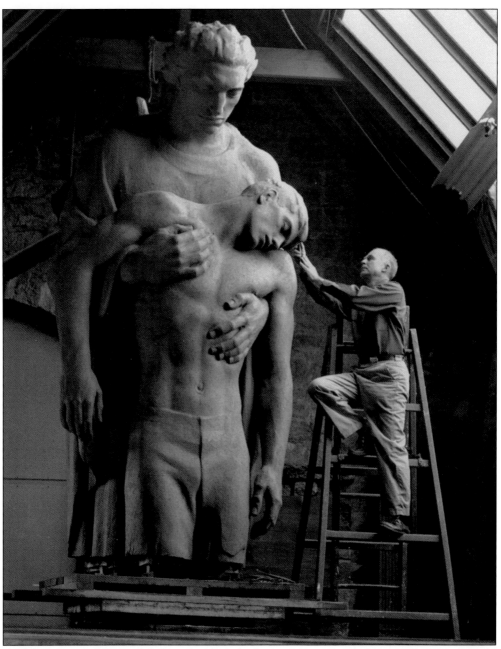

Walker Hancock (1901–1998), famed sculptor and one of the original Monuments Men of World War II, bought the Cheves Quarry at Devil's Rock in the early 1930s. It is sometimes referred to as Hancock's Pit after the sculptor, who located his home and studio near it. Here, he is sculpting his famous work for the Pennsylvania Railroad World War II Memorial. The 39-foot memorial is called *Angel of the Resurrection* (1950–1952) and is dedicated to the 1,307 Pennsylvania Railroad employees who died in the war and whose names are inscribed on its tall, black granite base. It depicts Michael the archangel raising up a fallen soldier from the flames of war. It was Hancock's favorite sculpture. A third-scale casting of this work is displayed at the Cape Ann Museum in Gloucester. Hancock and Paul Manship were close friends as well. (CAM.)

Three

PIGEON COVE QUARRIES

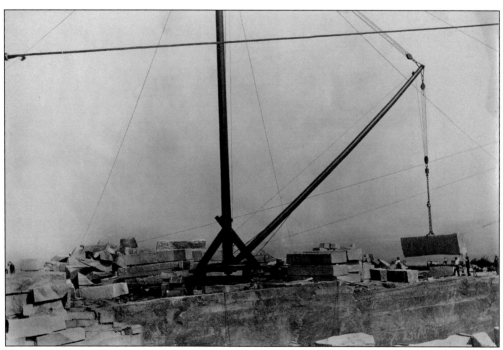

The quarries in the Pigeon Hill area were some of the most productive on Cape Ann. They were named Steel Derrick, Babson Farms Quarry (shown here), Big Parker, Little Parker, Canney's Pit (not to be confused with the one in Lanesville), Little Pit, Eames, Rice, Mason, Potato, Sheep Pasture Motions, Umiah's Pit, King, and Queen. (SBHS.)

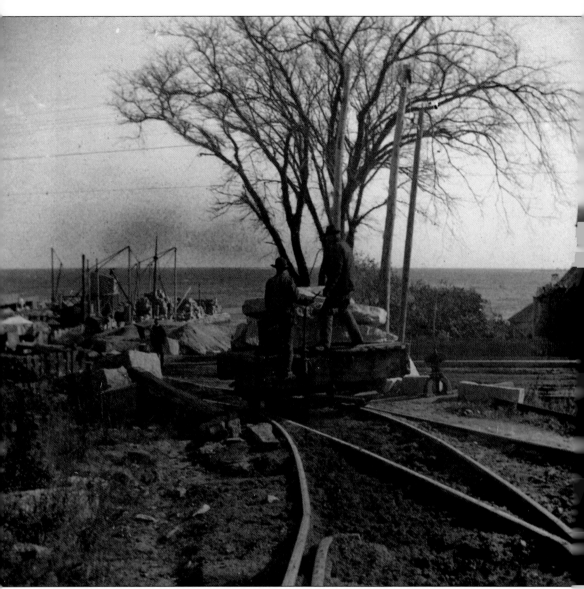

Flatcars carried stone on this inclined railway from Pigeon Hill Granite Company's Steel Derrick Quarry and Big Parker's Pit to its cutting shed and wharf shown in the far left of this photograph, at Colburn's Point. It passed across Granite Street, where a flagman was stationed to warn people walking or driving. The cars were gravity driven, and speeds were controlled by a crude handbrake. There are two men operating the brake wheel in this photograph. Sometimes when heavily loaded, they overturned on the curves. Many blocks of granite remain today where they fell. When unloaded, the car was dragged back up the hill by horses. A long cutting shed, where workers cut paving stones, was at the end of the line. The breakwater on which the cutting shed stood was manmade and had already been washed away by northeasters. A second one was built in 1930 and also lost. (SBHS.)

This is the Incline Railroad above Big Parker Pit, looking west toward Steel Derrick. This railroad relied on gravity for its power, and it culminated at the Pigeon Hill Granite Company breakwater and pier on Colburn Point, just below Granite Street. Big Parker Pit measured 625 by 700 by 500 feet across. It was 40 to 80 feet deep. (SBHS.)

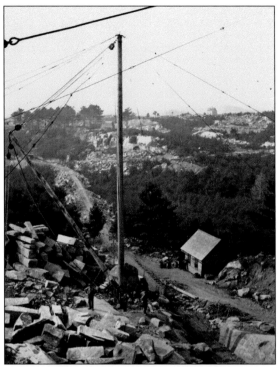

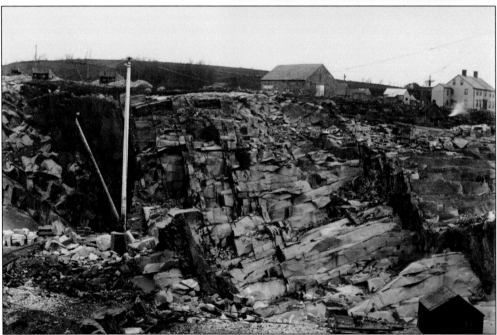

Big Parker Pit in Pigeon Cove was run by Samuel Parker and his brother William, who were in business in Rockport prior to 1830. The company's quarry pits in the hills, still called Big Parker's, Little Parker's, and Steel Derrick, were to become the main quarries of a new company called the Pigeon Hill Granite Company, which was formed in 1870 by George Bradford, Levi Sewall, and Amos Rowe. (CAM.)

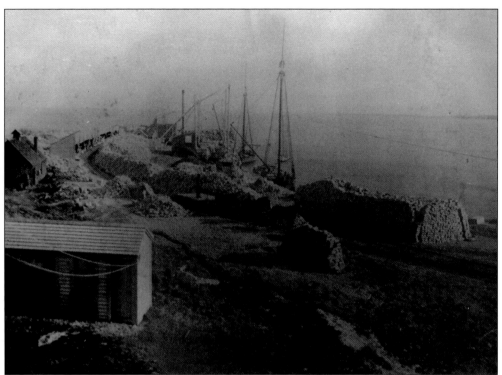

There are over 400,000 paving stones awaiting shipment here at the Pigeon Hill pier at Colburn Point. The railcar is pulled by four horses heading back up the hill to Pigeon Hill Granite Company quarries at Big Parker, Little Parker, and Steel Derrick. The paving cutter's bunkers are on the upper left. (SBHS.)

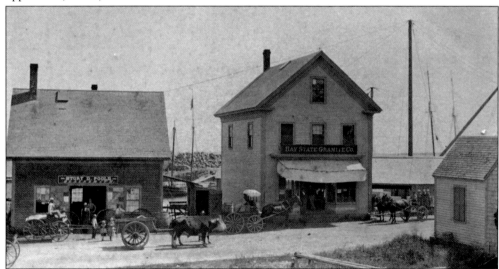

The Bay State Granite Company store and office is pictured here in Pigeon Cove. Next door is Story D. Poole's blacksmith shop. The Cape Ann Tool Company now occupies this site. Note the oxen pulling the heavy granite carts and the stone sloop's masts in between the buildings in the rear. Most granite companies had their own stores where the workers could buy their food and supplies. (SBHS.)

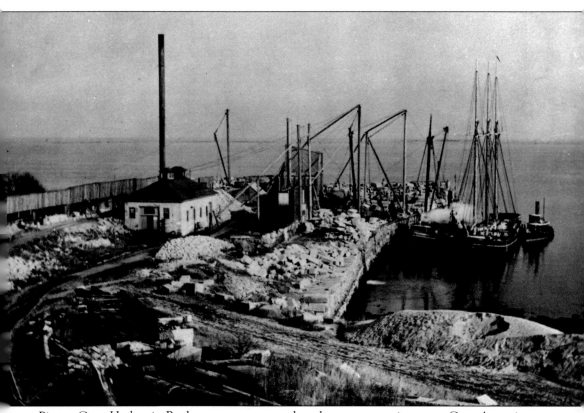

Pigeon Cove Harbor in Rockport was connected to the many quarries across Cape Ann via a rail system. This is Pigeon Hill Granite Company's wharf around 1879. On the left side, note the tracks that cross Granite Street from the quarry up on Pigeon Hill. Next are the cutting sheds where paving stones were made, and next to that is the newly built stone engine house (the original wooden one was burned down the year before) that provided power to the derricks and the stone crusher (the tall structure in the center). At the wharf are a stone barge and a three-masted schooner as well as a tugboat, all owned by the company. On the lower right is a pile of granite dust, which was sold for fertilizer locally because of its high potassium content, and granite chips were sold for road building. The company sold everything it could. One executive said they sold everything "except for the noise." The Rockport Granite Company eventually bought Pigeon Hill Granite Company in November 1914. The Pigeon Hill Granite Company lasted for 44 years. (SBHS.)

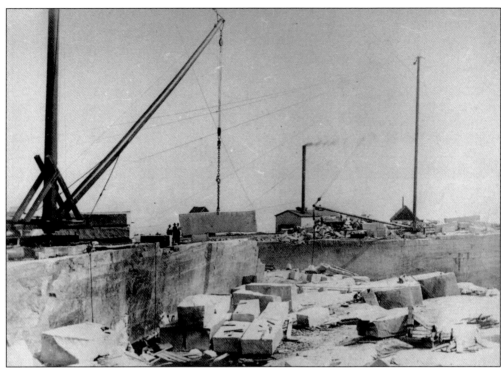

This image of the four-acre Babson Farm Quarry shows two derricks, one of which is lifting a 20-ton block likely to be used for the Sandy Bay breakwater. These large blocks were called headers and connected to each other by two-inch iron pins when placed on the breakwater. The quarry had four derricks during one of its busiest years. Rockport Granite Company bought Babson Farm Quarry for $40,000 in 1898. (SBHS.)

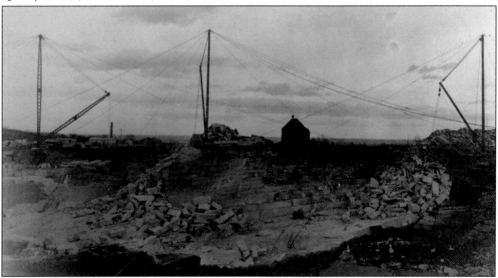

The older-style wood derrick on the right has masts and booms that measured from 50 to 75 feet, intended for lifting 20 tons. The mast was trussed in five planes and the boom in three planes by guy wires. Guy wires were run from the guy plate on the top of the mast to anchoring points set in solid granite or to "dead men," which were large blocks buried in the ground. (SBHS.)

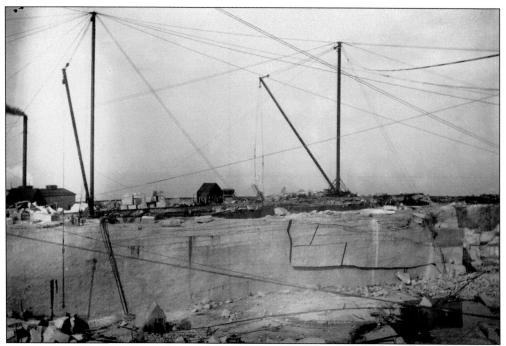

Derricks with a 100-foot boom can reach any point in a circle up to three quarters of an acre. They had three moving cables: the swing rope for swinging the boom into position, a boom rope that raised it, and the fall rope, which lowered the hook. Each derrick used a mile of rope and cable for all its lines. (SBHS.)

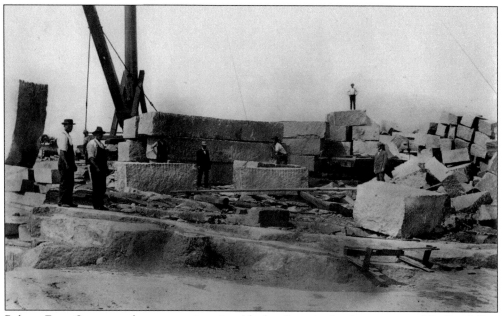

Babson Farm Quarry workers are cutting giant blocks of granite for the capstone of the Sandy Bay breakwater. The man on top of the block in the center is operating a plug drill, which he uses to split the block in half. The man in the dark suit is manager Henry Taylor, and the man on the far right is Louis Rogers, treasurer of the Rockport Granite Company. (SBHS.)

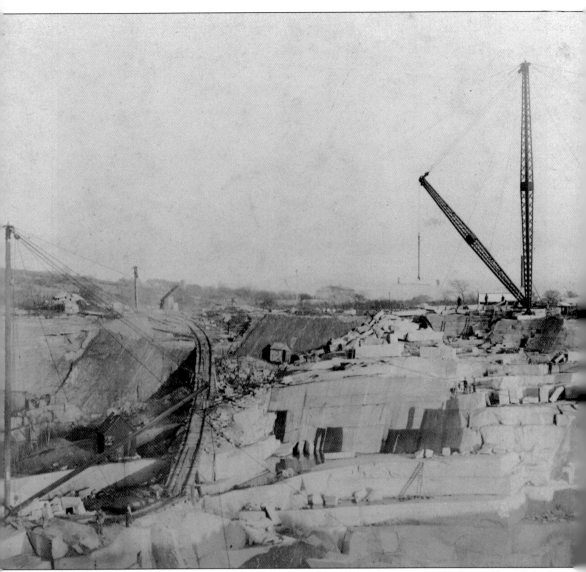

The steel derrick on the right was built in the early 1900s. It had masts 110 feet tall, and the boom was 80 feet long and could lift 100 tons. It followed a patented design offered by New York City–based Milliken Brothers. This quarry was originally called Upper Pigeon Hill Pit, but when the giant steel derrick was installed, the name soon changed to Steel Derrick. The railroad track on the left, headed down to Granite Street, was called an inclined railway. It started at Steel Derrick and went to Parker's Pit then on down to their new breakwater and pier on the other side of Granite Street. The local newspaper called it a gravitation road, as the stone cars were rolled down by gravity and pulled back up by horses. Steel Derrick was 800 feet by 400 feet and 50 to 100 feet deep, and the quarry is filled with water today. (Both, SBHS.)

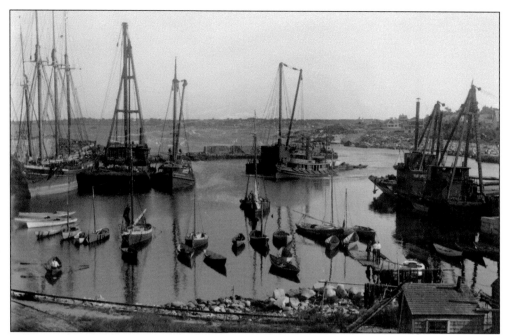

In Pigeon Cove Harbor, the tug *Confidence*, on the right, is bringing in a lighter. In the center is the steam lighter *William H. Moody*, and to its left is the barge *Commander*. To the left of that is the four-masted granite schooner *General Adelbert Ames*. The dories belonged to local fishermen, and their fish shack is in the lower right, with nets drying outside. (SBHS.)

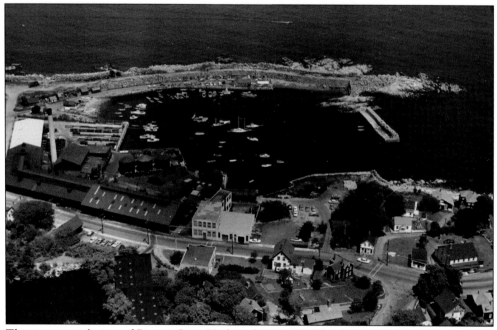

This is an aerial view of Pigeon Cove Harbor about 1980. The Cape Ann Tool Company on Granite Street is at the bottom left, and the rest of the harbor has changed since the granite business ceased in 1930. Today, it is inhabited mainly by lobstermen and their fishing boats and a few private sailboats. (SBHS.)

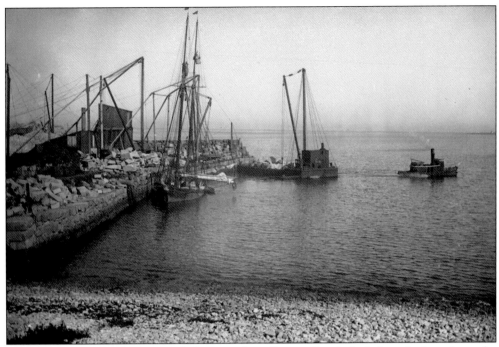

The tugboat *H.S. Nichols* tows a lighter out from Pigeon Cove's dock for a day's work on the breakwater around 1910. She is loaded with grout used to build the foundation. A stone sloop awaits its load of paving stones at the wharf side. (SBHS.)

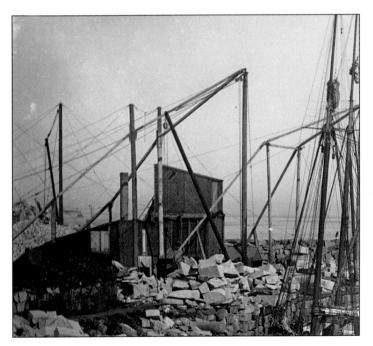

In Pigeon Cove, "stiff-leg" derricks were employed, as evidenced in this photograph. A stiff-leg derrick uses solid wood beams behind the mast instead of guy wires. These beams are connected at various places to make them more stable. Here on the wharf, they were used strictly to load the stone ships and only had to swing out over the vessel to do so. (SBHS.)

This is the railroad bridge from Babson Farm Quarry to Folly Cove dock, where granite was shipped out by quarry owner Edward Canney. Located on Granite Street, the building no longer exists but has been replaced by a "lobster in the rough" restaurant, and picnic tables are spread along where the paving stones are piled. The bridge is gone, but the abutments are still evident. (SBHS.)

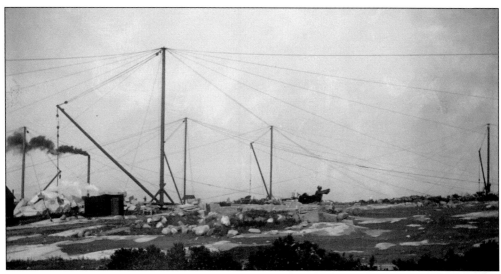

Here, one can plainly see the supporting guy wires from four derricks, called "sky guys," emanating from the guy plates at the top of the masts. The engine house is running wide open, as noted by the black smoke coming from the stack. Note the Model T Ford in the center with its top down. (SBHS.)

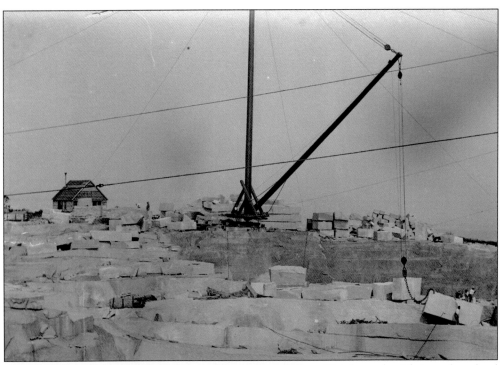

This huge derrick is ready to haul a giant block out of the quarry using "dog hooks." Each piece was drilled on either side with small indentations called "dog holes" in which the hooks were inserted. The man at the base of the "bull wheel" or turntable of the derrick next to the mast is dwarfed by mast pole, which is three feet in diameter. (SBHS.)

OFFICE OF

PIGEON HILL GRANITE COMPANY,

CONTRACTORS FOR FURNISHING

Best Monumental # Building Granite, Paving Blocks, &c.

QUARRIES AT ROCKPORT, MASS.

Members Master Builders' Association, 166 Devonshire St., Boston.

F. SCRIPTURE, - Treasurer.

ROCKPORT, *July 27th* 189 4.

Chas. S. Rogers Esq:
Treas: Rockport Granite Co.
Dear Sir.
We
wish it understood that we claim
the right to deposit our Share (1/3)
of the Large Stone required by the
contract to furnish Stone for the
Sandy-Bay Breakwater in which
Rockport Granite Co. and Pigeon Hill
Granite Co. are cocontractors.
Very Respy.
Pigeon Hill Granite Co.
by F. Scripture Tr:

This is a letter from Frank Scripture, president of the Pigeon Hill Granite Company, to Charles S. Rogers, treasurer of the Rockport Granite Company, confirming their agreement that Pigeon Hill would supply one third of the stone for the Sandy Bay National Harbor of Refuge breakwater in Rockport and work as co-contractors on the project. (SBHS.)

44

Four

ROCKPORT QUARRIES

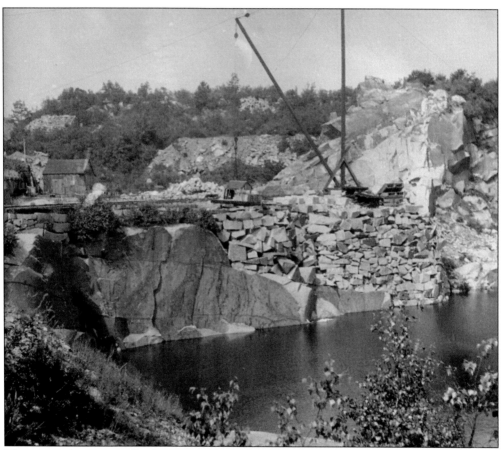

The principal quarries in Rockport were Flat Ledge, Old Pit, Johnson's Quarry, Carlson's Reservoir (often called Upper Pit), and Butman's Pit. Flat Ledge, founded around 1835, was one of the first large-scale quarries on Cape Ann, and Johnson's was the last one to close, in the 1950s. (SBHS.)

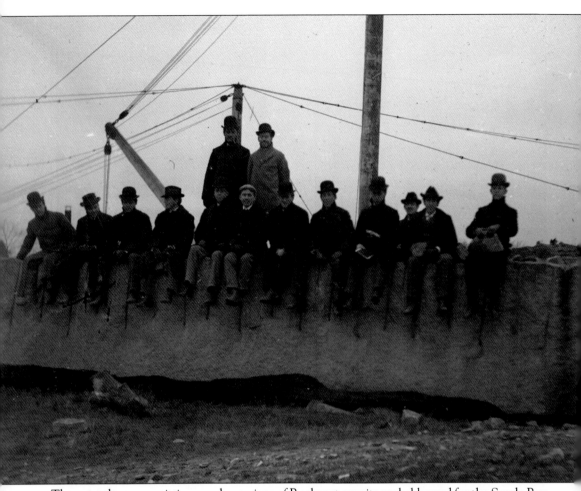

These gentlemen are sitting on a huge piece of Rockport granite probably used for the Sandy Bay National Harbor of Refuge breakwater in 1898. The area of present-day Rockport was originally a part of Gloucester and informally called Sandy Bay. It was decided in 1837 to form a committee to develop plans to separate this area from Gloucester, and the first priority of the committee was to decide on a proper name. On April 5, 1839, a vote was taken on a name for the new town. Names considered were Rockport, Cape Ann, East Gloucester, and Granite. When the final vote came on January 1, 1840, Rockport received 40 votes while the closest second was Granite, which received only 10 votes. Rockport was officially incorporated as a town on February 27, 1840, and it certainly lived up to its new name—30 quarries were within the town limits. (SBHS.)

QUOTATIONS SUBJECT TO PROMPT ACCEPTANCE. ALL AGREEMENTS ARE CONTINGENT UPON STRIKES, ACCIDENTS AND OTHER DIVERSE CAUSES BEYOND OUR CONTROL.

Organized 1864.

Capital $300,000.

BOSTON
31 STATE ST.,
NEW YORK.
REPRESENTED BY
F.E.FOSTER,
21 PARK ROW.
CHICAGO.
REPRESENTED BY
J.D.DUFFY,
CHAMBER OF COMMERCE BLD'G

Rockport Granite Co.

DEALERS IN
ROUGH HAMMERED & POLISHED
GRANITE
RED, GREEN AND GRAY
FOR BUILDINGS, BRIDGES AND ALL PURPOSES.

QUARRIES AT
ROCKPORT, MASS.
BAY VIEW, MASS.
PIGEON COVE, MASS.
JONESPORT, MAINE.
PAVING BLOCKS
OF ALL KINDS.

MAIN OFFICE, ROCKPORT, MASS.

CHAS.S.ROGERS, TREAS. & GENL.MGR.

ROCKPORT, MASS. Nov. 1, 1912

This is the Rockport Granite Company letterhead from 1912. By this time, they had bought up most of the other granite quarries and companies around the cape and became one of the oldest and largest in the nation. Although their main office was in Rockport, they had branch offices in Boston, New York, and Chicago and by 1923 had additional offices in Philadelphia, Pennsylvania; Cleveland, Ohio; and Detroit, Michigan. (SBHS.)

This is the cover of a Rockport Granite Company sales folder published in 1923. They were very proud of producing the four 16-foot eagles for the Boston Custom House. The sales sheet read, "This noble King of the Air so well typifies the character and quality of Rockport Granite, that we have adopted it as our trademark with 'King of the Rocks' as our motto." (SBHS.)

Under the Eye of the Eagle

The Story of Rockport Granite

A True Hornblende Granite

ORGANIZED
IN
1864

ROCKPORT GRANITE

GRAY · SEA-GREEN · RED

"The King of Rocks"

ROCKPORT GRANITE CO.

ROCKPORT, MASS.

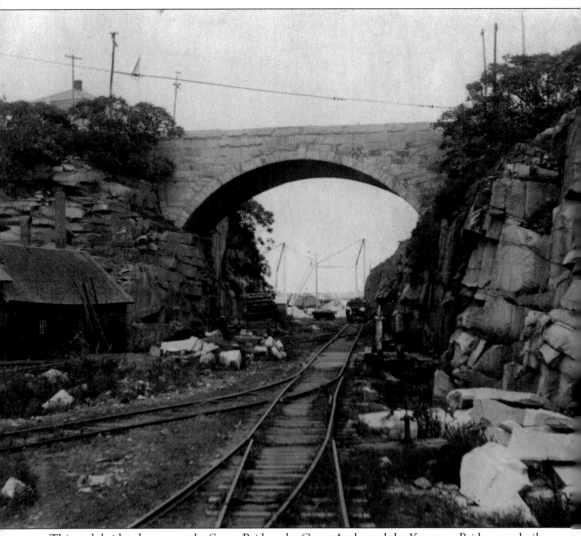

This arch bridge, known as the Stone Bridge, the Great Arch, and the Keystone Bridge, was built on Granite Street in Rockport by the Rockport Granite Company. The company needed to extract the stone from Flat Ledge Quarry behind it and bring it directly to the wharf at Granite Pier. They blasted through the rock to create an entryway, built the bridge, and laid track. It took four years to blast a tunnel through to allow the Great Arch to be built. This 65-foot span includes a keystone inscribed with the date 1872. The arch took 11 weeks to build and was completed on September 29, 1872, allowing traffic to continue on north to Pigeon Cove. Note the masts of the stone sloops at Granite Pier under the arch. (SBHS.)

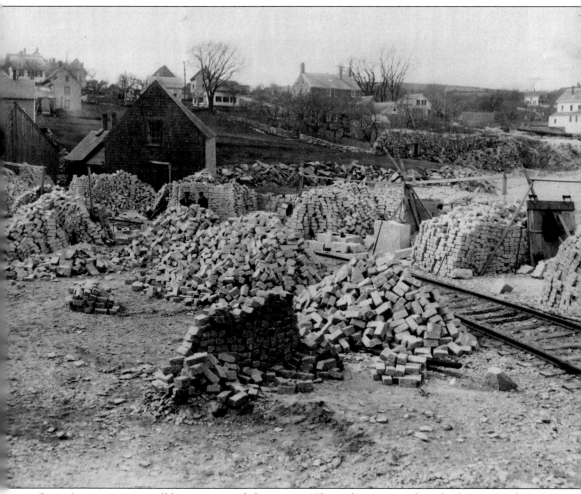

Cape Ann granite is well known around the nation. The industry started modestly in 1800, but over 60 quarries existed at its height, employing over 2,000 men. Paving blocks were the mainstay of the industry. Cape Ann granite paved the streets of Boston, New York City, Philadelphia, New Orleans, San Francisco, and many more cities across the country. Paving stone came in 30 sizes as the business developed. While paving blocks were generally 4-by-10-by-8-inch pieces, there were subtle differences. This led to some to be referred to as New York, Philadelphia, Boston, or Washington blocks, based on each city's individual size requirements. In 1906, the Rockport Granite Company accepted a big contract for blocks to be sent to Havana, Cuba, which required its own particular size. Later, smaller stones referred to as Belgian Blocks, rough cubes of stone five inches by five inches by a depth of six to seven inches, were created for many cities. (SBHS.)

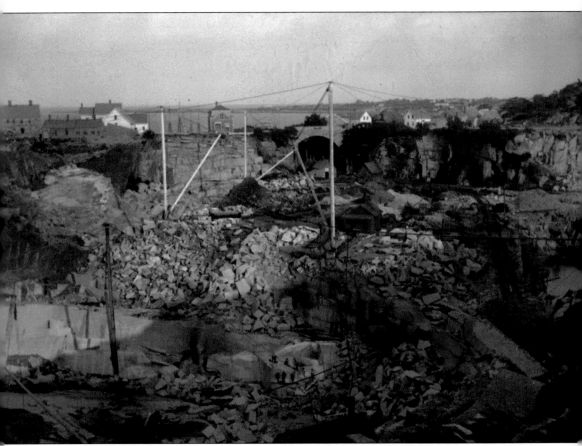

Flat Ledge Quarry was started by the Gloucester and Boston Granite Company in the 1830s. It was originally called John Swan's Pit. It became the first large-scale quarry on Cape Ann and by 1905 was producing 32,000 tons of paving stones and 92,000 tons of rip-rap and rough and finished stone. Flat Ledge measured 1,100 feet by 1,000 feet and had a depth of 120 feet. It had a cutting shed and 1,500 feet of track that led to the wharf at Granite Pier, where the stone was loaded on stone sloops and schooners. The Great Arch, or Keystone Bridge, can be seen in the upper center as well as the Rockport Granite Company office building just to the left of the bridge and the masts of the sloops just to the left of the office. It boasted 14 derricks and provided stone for Fort Warren in Boston Harbor. Upon close inspection, one can see the trolley passing over the bridge between the derrick mast and the Rockport Granite Company office. Today, it is filled with water supplying the Town of Rockport on an emergency basis. (SBHS.)

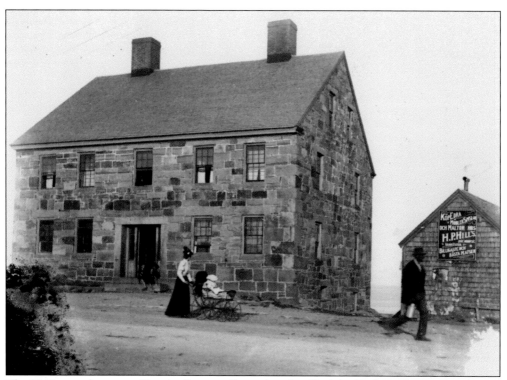

The 1840 stone house on Granite Street still stands today. Built by Zacheris Green, president of the Boston and Gloucester Granite Company, it was operated as a boardinghouse for quarrymen. They paid $3.50 per week to board there, have their washing done, and partake in the noon meal put up daily. The man on the right is carrying his lunch pail to the quarry. The sign on the right is in Swedish. (SBHS.)

The Rockport Granite Company office was built adjacent to the Keystone Bridge in 1892. Thomas O'Hearn of Pigeon Cove carved the company name above the front door, and a stone slab from the Flat Ledge Quarry was polished to serve as a countertop. One innovative feature was a speaking tube that connected the office with the company store. Upstairs was the drafting room. (CAM.)

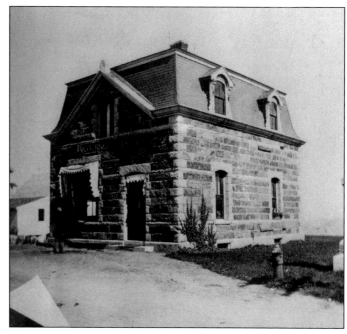

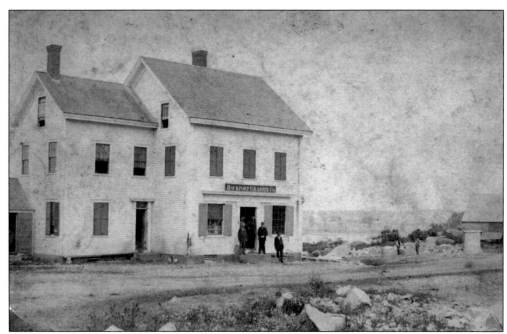

The company store on the north side of Granite Street was packed with items needed by the quarrymen: files, barrels of flour, sea boots, fishing line, hatchets, oilskin jackets, pickaxes, nails, and plug tobacco. They stocked cheeses, cold meats, ham, codfish, molasses, and kerosene. It was the custom that the quarrymen kept a charge there, and when payday came, they paid what was owed. (SBHS.)

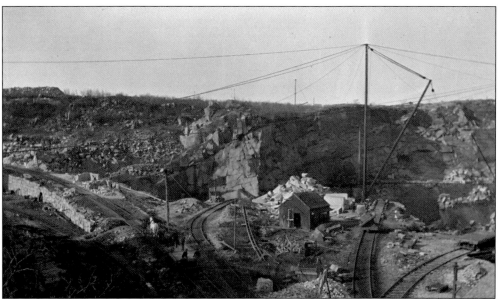

Looking back into Flat Ledge Quarry from the bridge are the various tracks for the railroad and a horse towing one of the railcars back up to the Upper Pit, with workers hitching a ride. In the center is the quarry office and cutting shed, and a railcar stands at the siding with its bed tilted up, having just unloaded a block. (CAM.)

Here is a seldom-seen photograph of a seam being blasted on the upper ledge. The term quarrymen used was "shooting" the ledge. Black powder was used instead of dynamite because it was a low explosive, meaning it simply loosened the stone and did not break or shatter it. The man standing near the derrick was probably the powder man who set the charge. (SBHS.)

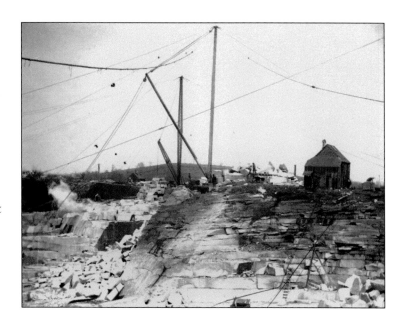

A typical grout pile is made up of unusable granite scraps. Grout was used as rip-rap for breakwaters or eventually crushed up for gravel. The Rockport Granite Company reported in 1930 that they had supplied rip-rap for building breakwaters for the government along the coast from Portsmouth, New Hampshire, to Galveston, Texas. This grout pile is located at the Babson Farm Quarry in Rockport. (Author's collection.)

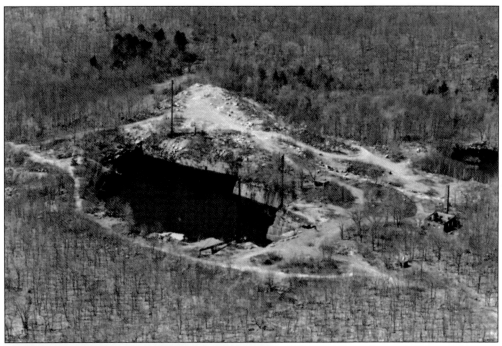

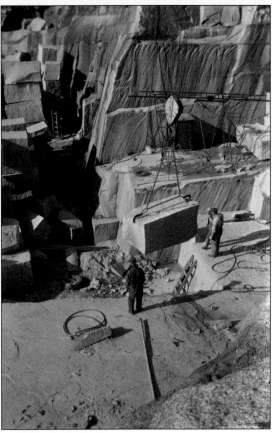

This is an aerial view of Johnson's Quarry taken 50 years ago. To the right are the remains of the power house, totally flooded by groundwater now. It was originally opened as a small paving-block motion by J. Leonard Johnson, a Swede, in 1898 and later enlarged to 64 acres. Johnson once estimated that 1.5 million blocks had been cut in his quarry, and that was not counting the monument stock and other random stone. Stone from this quarry was used to build the post office in Gloucester in 1934. The Providence Granite Company leased Johnson's works in 1956 as a source of 20-ton blocks, which they sawed at their cutting shed at Providence, Rhode Island. They had to pump out some 50 million gallons of water to get to the stone. At left, Merrill Knowlton of Maine, in the foreground, directs a heavy lift in 1958. It was the last operating quarry in Rockport. (Above, SBHS; left, CAM.)

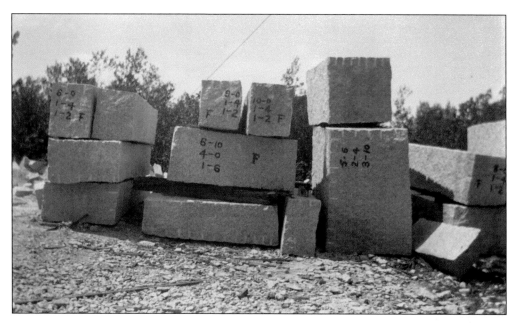

Dimension stone refers to granite used for buildings, foundations, walls, or memorials. Dimension building stone had to be cut according to a blueprint and numbered so that the builder could assemble them correctly (above). Each stone had to be cut precisely, using little more than a straight edge and an experienced eye as a guide. Granite could be delivered rough cut or dressed (stone that was smoothed or polished). When stone was shipped dressed, each piece was packed in wooden crates to protect the edges and surface dressing while in transit (below). (Both, SBHS.)

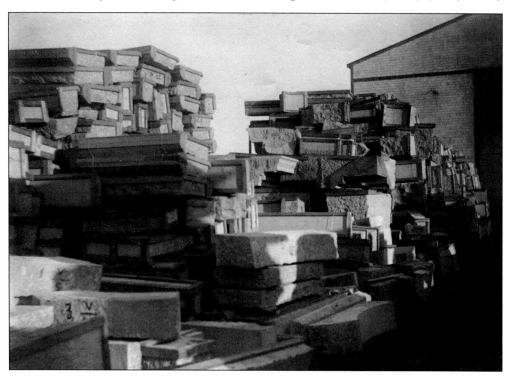

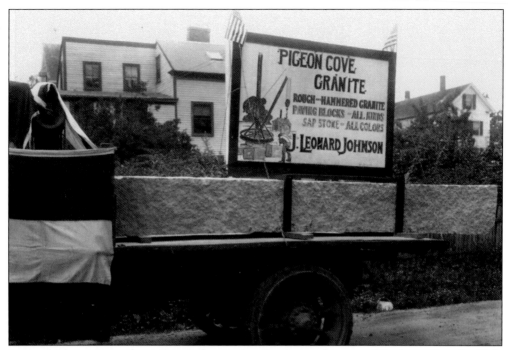

Leonard Johnson's parade truck was always a favorite during the annual Rockport Fourth of July parade. He never missed an opportunity to advertise to the home folks. His truck carried this 33,000-pound slab of granite through the town. (SBHS.)

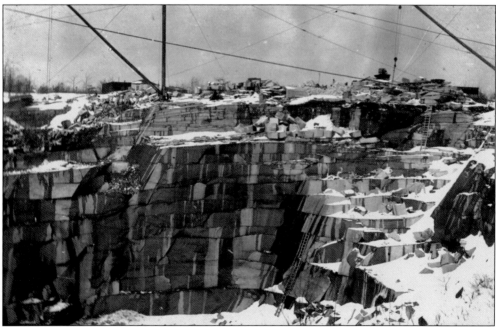

Here in Johnson's Quarry, very little work was done during the winter when it was hardest to get the granite out, not only because of the dangerous snow and ice, but also warmer granite split straighter and easier than cold. The men made up their work time during the winter by cutting paving stones. By the spring, thousands of stones were waiting at the docks for shipment. (SBHS.)

This view of Flat Ledge is taken from the Keystone Arch Bridge. The sheds are used for power to the derricks, pumping stations, storage, and offices. This photograph shows three derricks, a railcar, the power house with the tall chimney in the background, and the blacksmith shop on the far left. (SBHS.)

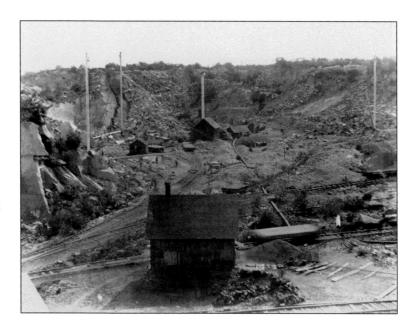

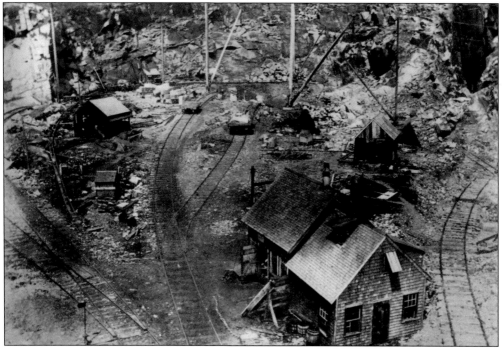

This photograph of Flat Ledge Quarry shows many railroad tracks all heading toward the main ledge. Each track has a derrick at its end to load cars as they take the ledge down piece by piece. In the foreground is the engine house; note the skylight doors on the roof and the side to let in cool air. A small paving-stone cutter's bunker is in the upper left. (SBHS.)

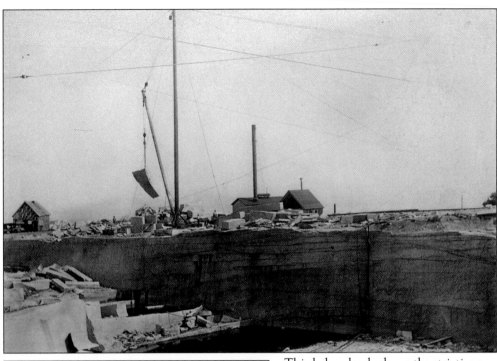

This ledge clearly shows the striations, or seams, in the granite shelf. This is called a "sheet" quarry for the exposed horizontal sheets that follow the natural fault lines. The use of boom derricks like this one allowed the development of deep pit quarries. The best granite was found at the lower layers. This derrick is lifting a large sheet of granite here. (CAM.)

This Rockport Granite Company sales flyer gives details about the quality of their granite. "This Granite is free from knots and seams, and owing to the absence of pyrites and other sulphides, it does not stain by action of the atmosphere." It ends with a testimonial by the commissioner of public works of New York City about the quality of the paving stones on many city streets. (SBHS.)

Five

The Quarrymen

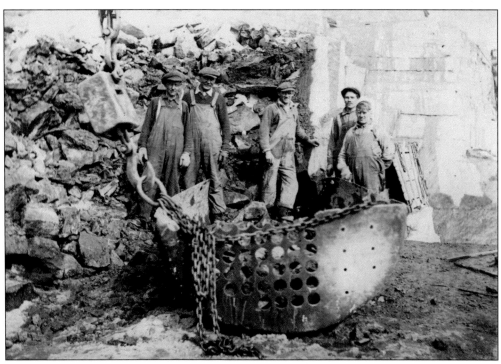

Pictured here in Annisquam in 1910 are, from left to right, Jacob Humlin, Victor Suutari, Eric Pearson, John Mackey, and unidentified. Also called a ride bucket, the grout box was used to ferry the men back and forth into the deep pits, saving them the time and effort to climb out up the ladders after a hard day's work. Its principal use was to lift grout scraps out of the quarry. (SBHS.)

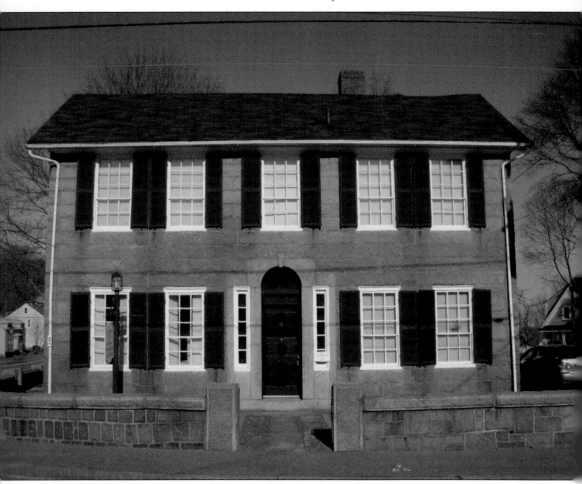

Sewall-Scripture House, now the home of the Sandy Bay Historical Society, was built of gray granite by Levi Sewall for his bride, Mary Roberts, in 1832. They moved in to the newly completed home on their wedding day. Sewall was a stone cutter with Proctor, Fernald & Company. In 1870, the Pigeon Hill Granite Company was formed by Sewall and three other partners. Later, Frank Scripture, who married Sewall's daughter Mary, joined the business and lived in the house with the Sewalls. Levi Sewall lived there for 48 years and died in this house. Upon Sewall's death in 1880, it passed on to his daughter and Scripture. It was purchased by the Sandy Bay Historical Society in 1957 and continues as a museum and research center housing many historic relics from the town of Rockport, including an excellent granite quarry exhibit. (Author's collection.)

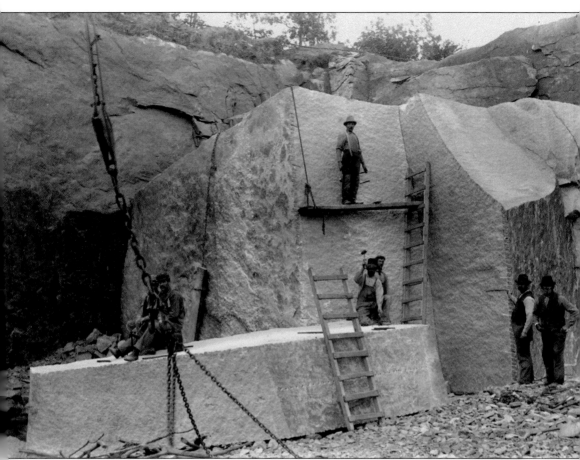

The foreman on the right in Cheves Pit measures the next cut of granite, possibly for capstone for the Dog Bar breakwater in Gloucester. Workers at the quarries were put into four classes: quarrymen, stonecutters, paving cutters, and finishers. Over the years, jobs became more specialized. Titles such as marker, driller, bar runner, powder man, splitter, breaker, lumper, grouter, hoist engineer, derrickman, signalman, rigger, and steam fitter were created. Each crew was called a kit, usually made up of 12 or 13 men, which always included a young runner and a blacksmith. Each quarry employed at least one blacksmith who forged and sharpened the drills and wedges, made the hoisting chains, and shod the oxen and horses. Tool boys were paid 5¢ a day as runners to fetch water or sharpened drill bits or other tools for the quarrymen. (CAM.)

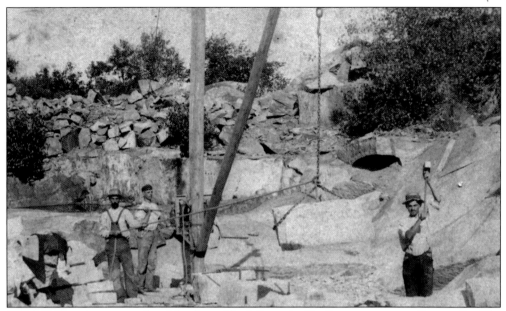

Quarrymen are posing as they lift a large block from the Shelburne motion in Lanesville. The man on the right poses with his 20-pound striking hammer. Granite was first split by inserting flat wedges between shims (thin pieces of steel) called feathers and plugs placed in the holes by a flat cape chisel. It was not until 1883 that a steam drill was used in the Rockport quarries to drill these cutting holes. (SBHS.)

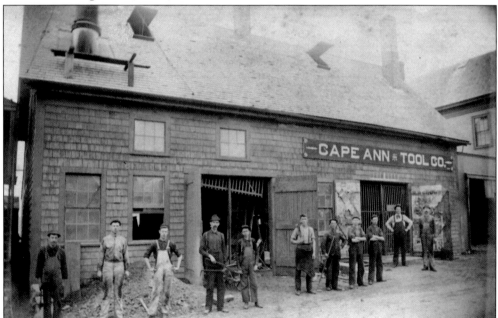

In the 1850s, Dyer Poole's blacksmith shop was sold to Henry Pingree. By 1890, Pingree had installed six steam-powered hammers and was providing an extraordinary line of products. Upon his death in 1891, his foreman, John M. Tuttle, organized a new company called the Cape Ann Tool Company. In 1913, this woodshed burned down, and a mammoth new metal structure replaced it in 1914. (SBHS.)

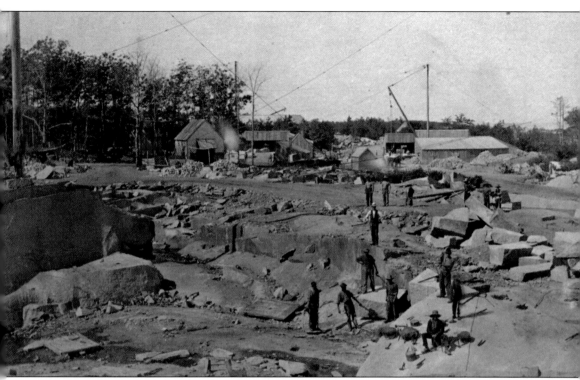

Quarrymen pause for a photograph at the Bay State Granite Company quarry in Lanesville. The seated man in the lower right has his hammers and plug drills spread out before him. Note to his left the stone has already been split. The men to his right are holding the dog hook chain under a block, which will be lifted by the derrick on the far left. Owned by James Edmunds and Gustavus Lane, they never went much beyond the cutting of granite for foundations, wharves, and paving, although they cut stone for a lighthouse, probably Race Rock on Long Island Sound near New London, Connecticut. They kept 50 oxen in small barns close to their main quarries, Bay State and Pine Pit. The company was the first to hire Finns, who came to live at the Stone House in Rockport near the Keystone Bridge. Names such as Andrew Oya, Matthew Viahaja, and Erike Seike first appeared in the company's ledger entries in December 1874. Bay State folded in 1879, becoming the Cape Ann Granite Company bought by Col. Jonas H. French in 1894. (SBHS.)

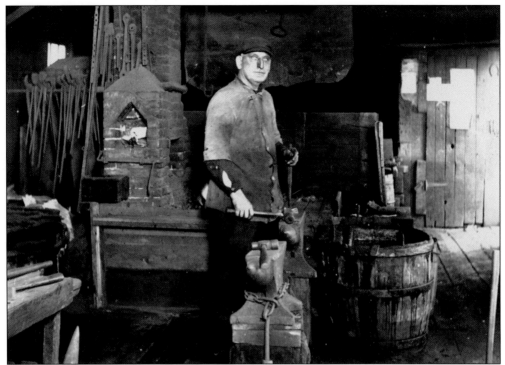

Blacksmiths were an essential part of any quarry works. This is a blacksmith employed by the Cape Ann Tool Company. It was noted that at least one blacksmith was required for every 10 or 15 quarrymen just to keep their tools in top condition. Blacksmiths repaired, sharpened, and tempered granite tools as well as designed and fabricated simple tools. They also made shoes for the horses and oxen. (SBHS.)

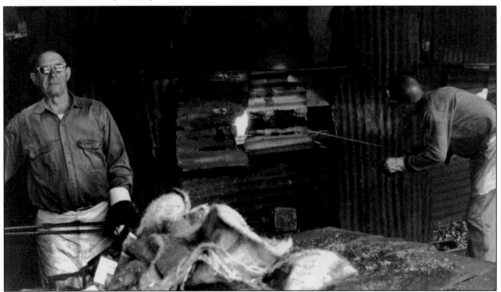

Men worked the furnaces at the Cape Ann Tool Company as late as 1970. Tongs, asbestos gloves, and special glasses were required at the forge. The only safety equipment used by quarrymen before 1890 was safety glasses. Most men seldom used gloves. (SBHS.)

This is a tintype image of the McInerney family of Bay View, one of the first three Irish families on Cape Ann. Irish immigrants first arrived in the mid-1830s as a result of the famine in Ireland, and the Finns came in the 1870s, with the Swedes following soon after. (CAM.)

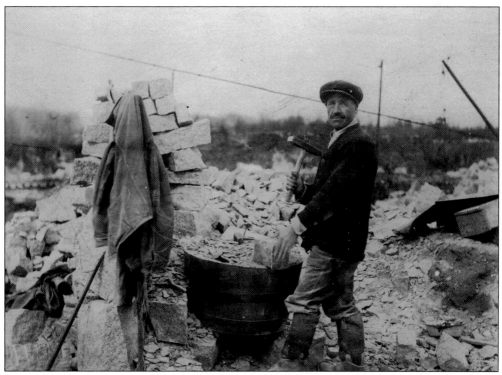

Finnish paving cutter Salomon Hautamaki is pictured here at his chipping tub. Finnish quarry workers wore leather boots with turned–up toes, short blue coats, and neat blue pants. Hautamaki is holding a chipping hammer called a reel hammer, used to smooth the edges and obtain the appropriate sized block. The wooden tub is filled with granite chips to give him a solid base for cutting and shaping the blocks (CAM.)

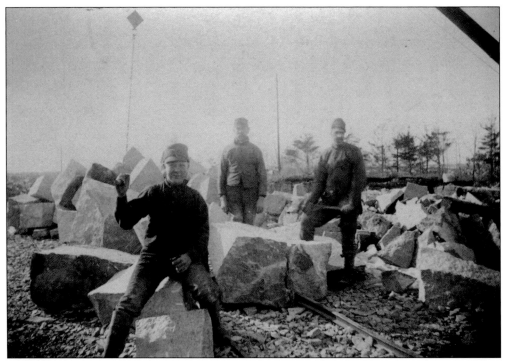

Matt Haupa is pictured holding his paving stone hammer with two of his mates. He is sitting on a block in the Cheves Quarry. Note that the stone has been dropped right on the railway tracks, and the men are in the process of removing it by splitting the block. (CAM.)

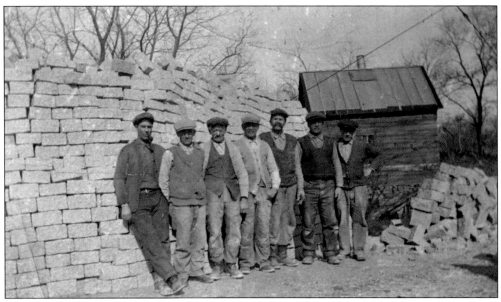

Woodbury Hill paving cutters were all Finns. From left to right are John Hill, Salomon Hautamaki, Nestor Niemi, Matt Ray, John Mylly, unidentified, and Mike Aho. In no time they became skilled in cutting stone, working with a great deal of strength and endurance. (CAM.)

Leather-covered monthly time books such as these were the way managers recorded each worker's hours of work. Similar notebooks recorded each man's production of paving stones. A page from one of these books recorded on July 5, 1870, that 28 men had produced a total of 12,673 pavers. Pictured here are Levi Sewall's time book for February 1866 (left) and one from the Rockport Granite Company dated March 1874 (right). (SBHS.)

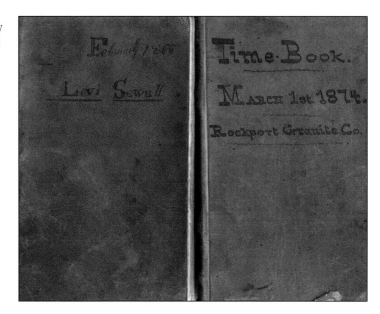

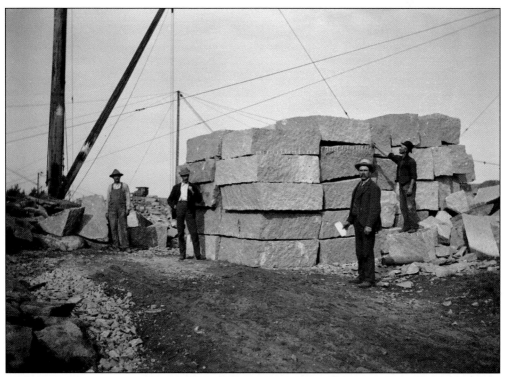

William R. Cheves, second from right with an order book, and his son Alexander, second from left, are flanking an order of dimension stone to be shipped out around 1905. Alexander Cheves became a photographer, and many of the photographs featuring Cheves quarries were taken by him and are in the collection at the Cape Ann Museum. (CAM.)

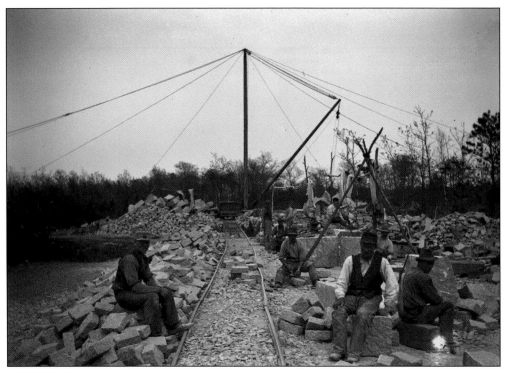

These men are paving stone cutters in their positions along the railway track at the Cheves Green Granite Quarry around 1910. Tree limbs form frames for sun and wind shelters when needed. On Saturdays, 1,200 men stepped up to the paymaster's window at more than a dozen large granite companies and 50 motions by the end of the 19th century. (CAM.)

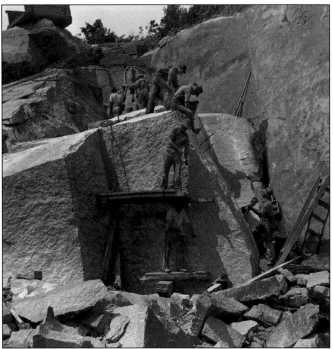

These three Cheves Quarry crews are drilling holes along chalk and tracer lines laid out by the lead quarryman. They stand on two levels of scaffolding. This drilling is all being done by hand, and plug drills can be seen in the rock. The top team is cutting plugholes for the back seam while the two below on the scaffolding are drilling the side and bottom holes. (CAM.)

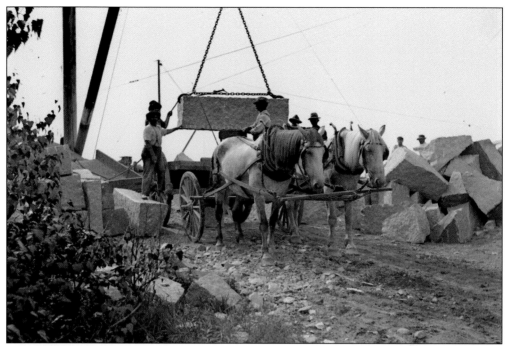

Around 1900, workmen load a five-ton block of granite dimension stone onto a granite cart, sometimes called a jigger, on High Street in Lanesville. Cheves maintained a stable for his dray horses and oxen on the quarry site. (CAM.)

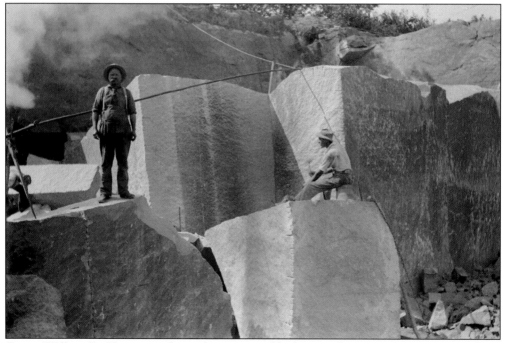

Owner William R. Cheves stands on a huge granite block on High Street. The steam line behind him is connected to a steam drill on the far left used to make the cutting holes. Note the six-inch-deep scored lines indicating where the split was made and how evenly it was done. (CAM.)

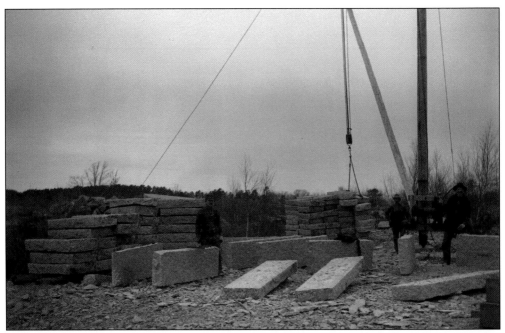

The derrick crew is lifting curbstone using dog hooks. The man at far right is hammering the edge to make a "dog hole" to insert the hooks for lifting. The man standing next to him is the derrick operator, while the third man smoking his pipe is measuring the stones that will be chosen to ship. Each curbstone weighed in excess of 600 pounds. (CAM.)

A tilt-bottom railcar at Cheves Quarry delivers a granite block. The paving cutter on the left will reduce that block to many smaller paving stones, and this block will provide at least 200 pavers. A good paving cutter could earn 5¢ a block and cut about 275 blocks a day. (CAM.)

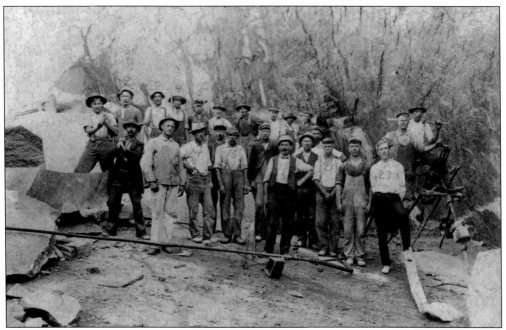

This is a steam-drill crew at an unknown quarry in Rockport, with the steam drill on the right and the steam hose pipe passing in front of them. Quarrymen drilled holes six to eight feet deep in a zigzag pattern over the area to be raised. They poured in black powder, tamped it down, laid a fuse, and plugged the hole with clay. Then, all holes were fired at once. (SBHS.)

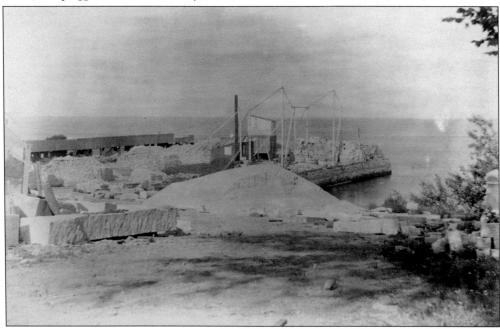

The mound in the center of this photograph is a granite dust pile at Pigeon Hill Granite Company wharf. "Stonecutter's consumption," or silicosis, was a feared lung disease caused by exposure to stone dust. In 1915, an analysis of the death certificates for the past 20 years on Cape Ann indicated that 86 percent of the stonecutters died from silicosis or tuberculosis. (SBHS.)

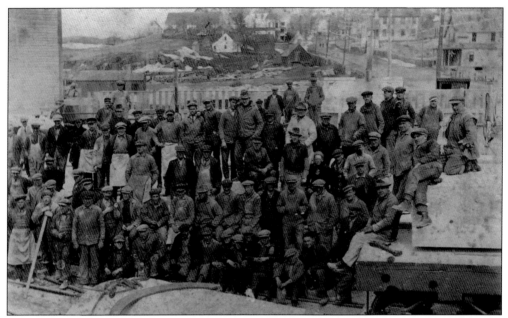

According to the *Cape Ann Advertiser* of May 20, 1892, there was a strike of over 50,000 quarry and stone workers nationwide. The number of strikers reported on Cape Ann were, Bay View 500, Lanesville 2,000, Rockport 2,000, and Pigeon Cove 500. Strikes occurred again in 1901 and 1922. The men wanted the workweek reduced from 44 hours to 40 and wanted a raise from $8 to $9 a day. (CAM.)

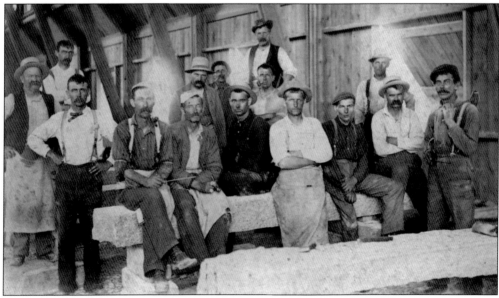

On April 26, 1922, more than 200 quarry workers marched from Lanesville to Rockport for a mass meeting in the Rockport Town Hall. They were against the proposed open shop in which one is not required to join the union as a condition of employment, which the company wanted. A compromise agreement was reached on February 1, 1923. Unfortunately, these strikes spelled the beginning of the end of the Rockport Granite Company, which announced it was closing down in June 1930. (SBHS.)

The Union Store in Pigeon Cove was where workers shopped for equipment and household needs. Part of the employment agreement each worker had to sign was that he do all his shopping at the company store. The advertising signs on the wall feature Savena Washing Powder, Pearline for Washing, Fleishmann's Yeast, Enameline Stove Polish, Fel-Naptha Soap, and Sun Paste Stove Polish. (SBHS.)

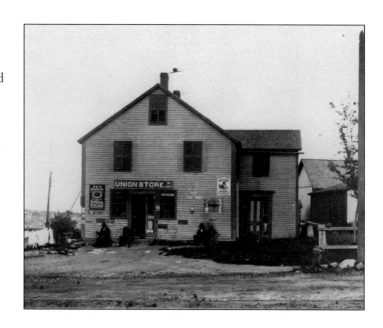

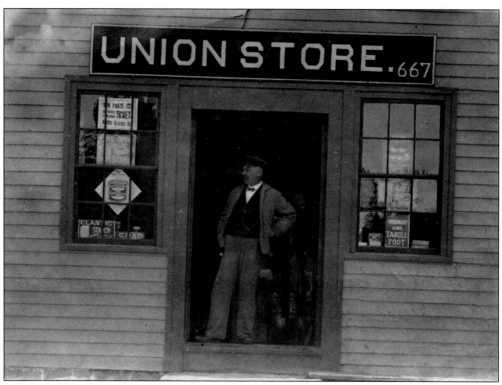

Thaddeus Wheeler ran the Union Store, located on Granite Street next to the Pigeon Cove Post Office and near Pigeon Cove Harbor. The advertising signs were interesting; one asks, "Troubled? Use Tangle Foot," another announces, "We Give Blue Trading Stamps," and a third says, "Elastic Starch." (SBHS.)

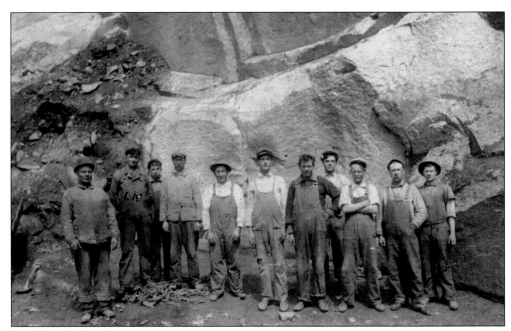

This is the Rockport Granite Company hoisting gang with their leader, head quarryman Lewis Norwood (second from the left). The head quarryman used hand signals to the derrick man to raise, lower, or swing the derrick. His team used riggers to secure all cables and guys as well as to grease the sheaves (pulleys). (SBHS.)

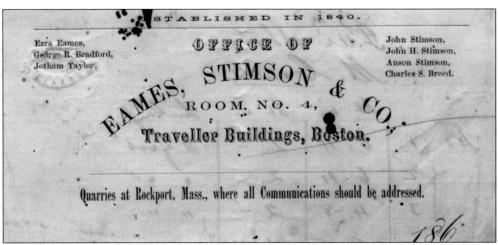

This is the letterhead of Eames, Stimson & Company, one of the earliest companies to supply granite in the Pigeon Cove area of Rockport, beginning in 1840. Ezra Eames, George Bradford, and John Stimson were the principals. The company had quarries in Bay View and Lanesville and at Flat Ledge in Rockport. The Rockport Granite Company was formed in 1864 by the principals of Eames and Stimson. (SBHS.)

Six

THE TOOLS

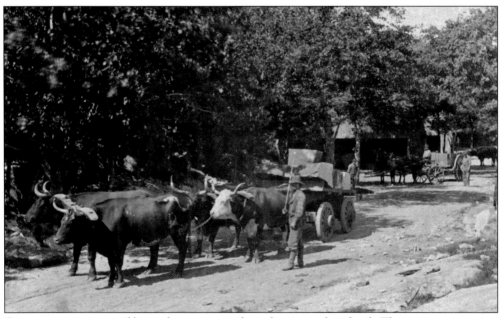

Quarry stone was moved by ox-drawn wagons from the pits to the wharfs. These oxen are coming from the Bay State quarries, probably heading to Lane's Cove docks to be loaded on stone sloops. The use of oxen diminished once quarry railroads were built, but they were still used to turn the derricks and perform other heavy lifting jobs. (SBHS.)

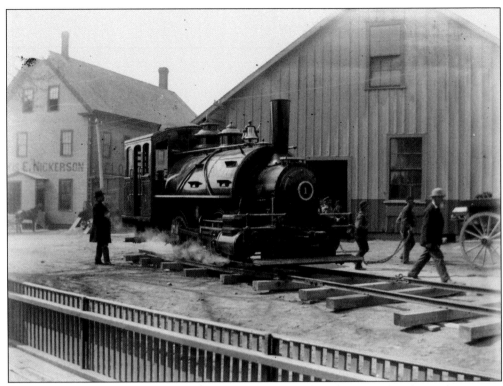

The new locomotive *Nella*, named for Col. Jonas French's wife, was delivered to the Rockport train station on a temporary track. This engine was noted for its bright brass bell, whistle, railings, and trim work. It ran on a 1.4-mile-long railway built with 60-pound standard-gauge rail on a roadbed two rods wide. The rail was stamped in two inch letters reading, "Sheffield, England." (SBHS.)

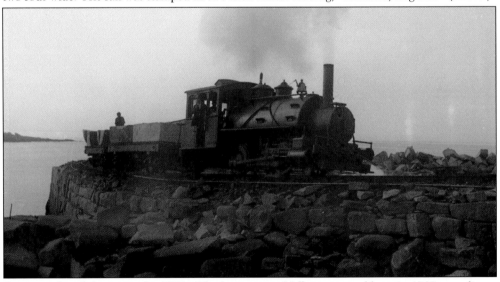

Quarry railroads began in the 1870s. The locomotive *Nella* is pictured here in 1909 rounding a curve near Folly Cove, its railcars loaded with granite. The train's longtime engineer was Blanchard Mitchell. Mitchell was originally the oxen master and herded them for many years up and down the quarries pulling wagons and railcars back up to the top from the wharf below. (SBHS.)

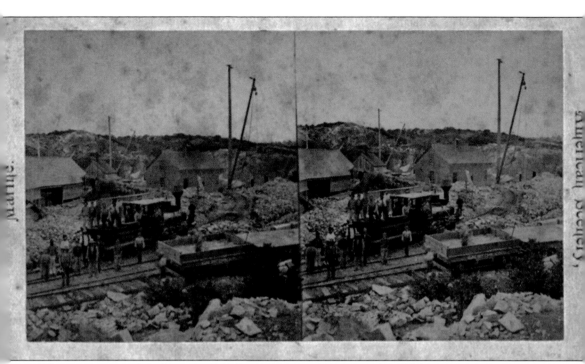

This stereopticon slide shows the *Polyphemus No.2* on the track at the Old Pit Quarry in Bay View. There were five quarry railroads on Cape Ann and three locomotives, the *Polyphemus No.2*, the *Nella*, and the *Vulcan*, which was operated by the Rockport Granite Company around 1912. The Cape Ann Granite Railroad went from Blood Ledge around Old Pit to Hodgkins Cove in Bay View, the Bay State Railroad went from Lanesville across to Pigeon Cove Harbor, the Incline Railroad went from Steel Derrick and Big Parker to Colburn Point in Rockport, and the Rockport Granite Company Railroad ran from Flat Ledge Quarry and Upper Quarry to Granite Pier wharf. In 1901, Edwin Canney built the last railroad in Folly Cove from his Babson Farm Quarry to a newly built wharf at Folly Cove, a length of 2,500 feet. It was an inclined railway operated with horses and oxen. (CAM.)

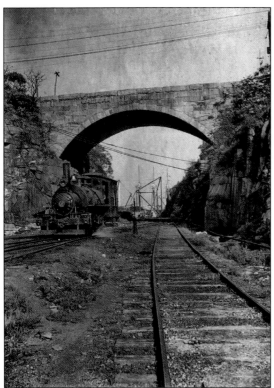

Here, *Nella* can be seen coming through the Keystone Bridge away from Granite Pier and into the Flat Ledge Quarry. The *Nella* was moved around to various quarries; it was sold by the Cape Ann Granite Company in 1910 for use at the Rockport Granite Company's Blood Ledge Quarry in Bay View. (SBHS.)

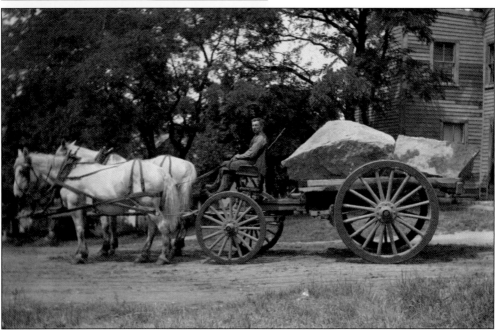

The Rockport Granite Company painted all their quarry vehicles, teams, jiggers, and sheds with blue paint. Workers bought the low-priced paint at the company store and used it on their fences, wheelbarrows, and farm teams. It became known as wagon-wheel blue and Finn blue. The Finnish people often painted their kitchen woodwork and sometimes their furniture with it. (CAM.)

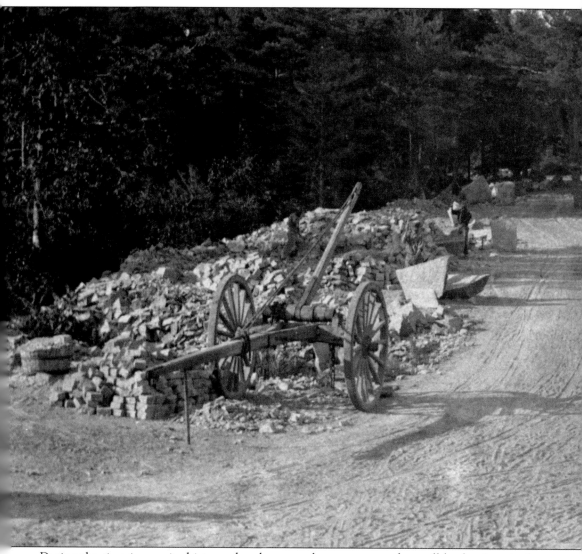

During the time in granite history when horses and oxen were used to pull loads, giant-sized, extra-heavy two- or four-wheeled wooden wagons called "garymanders" were built to do the work. Using a boom that was permanently rigged next to the rear axle, the quarrymen raised a stone and chained it into place under the wagon between the rear wheels. It was lifted high enough to clear the rough surface of the ground over which it would travel. Four oxen, guided by their drivers, pulled the load. The Cape Ann garymanders' wheels were eight feet high, made of solid oak and iron. Their wheel hubs were as big as nail kegs. Most of the garymanders in common use on Cape Ann were two-wheeled wagons with a boom. Jiggers (four wheeled wagons) were also used, sometimes carrying one giant stone. Platform wagons with extra strong artillery wheels were used for extra-heavy loads. (SBHS.)

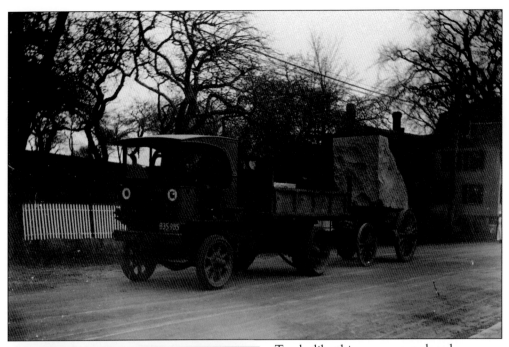

Trucks like this one soon replaced ox-drawn wood carts to haul granite. This one from 1900 is driving down Granite Street in Rockport with a large triangular piece of stone. (SBHS.)

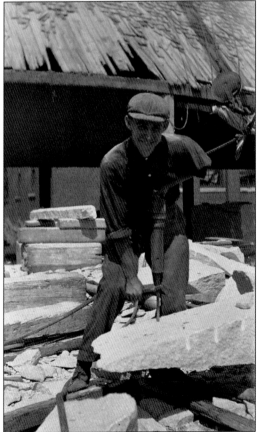

Pneumatic plug drills came into use in 1861 and were used to drill blasting holes. Operating on compressed air, they made holes 1.25 inches in diameter spaced six inches on center along a prescribed line. Blocks were usually shot or blasted using black powder, which lifts the ledge from seam to seam—usually in a straight line without shattering the rock. Dynamite was seldom used because it broke the stone. (CAM.)

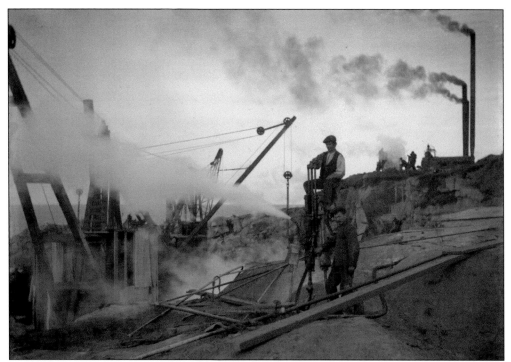

Steam drills were introduced in the 1880s, invented by Simon Ingersoll, a Stamford, Connecticut, native. They were made with tripod legs so that the operator could stand next to or on top of the rig to steady it and drill 2.5-inch holes in which black powder was placed to blast the stone free. This one was at Breakwater Quarry at Folly Point around 1910. (CAM.)

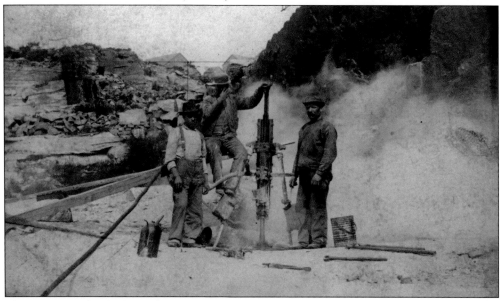

The most popular drill was the Ingersoll steam drill, which could carry holes to a depth of 15 to 18 feet, thus cutting larger pieces of stone. Groups of holes are drilled some feet apart, filled with a black powder cartridge, attached by wire to a common battery, and all the charges were exploded by electric current. Drills were usually run by three-man teams. (CAM.)

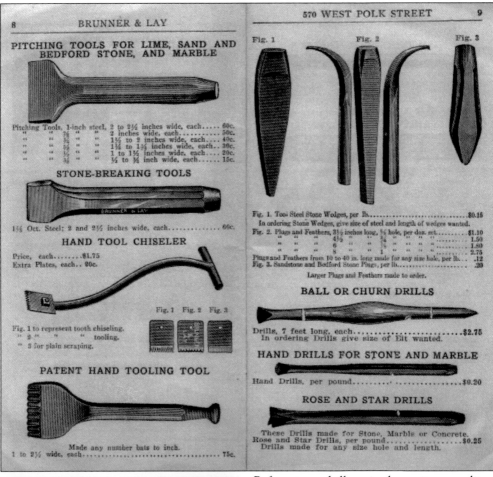

PITCHING TOOLS FOR LIME, SAND AND BEDFORD STONE, AND MARBLE

Pitching Tools, 1-inch steel, 2 to 2½ inches wide, each..... 60c.
" " ⅞ " " 2 inches wide, each............50c.
" " ¾ " " 1½ to 2 inches wide, each.... 40c.
" " ⅝ " " 1¼ to 1½ inches wide, each.. 30c.
" " ½ " " 1 to 1½ inches wide, each.... 20c.
" " ⅜ " " ½ to ¾ inch wide, each...... 15c.

STONE-BREAKING TOOLS

1⅛ Oct. Steel; 2 and 2½ inches wide, each.............. 60c.

HAND TOOL CHISELER

Price, each.......$1.75
Extra Plates, each.. 20c.

Fig. 1 Fig. 2 Fig. 3

Fig. 1 to represent tooth chiseling.
" 2 " " " tooling.
" 3 for plain scraping.

PATENT HAND TOOLING TOOL

Made any number bats to inch.
1 to 2½ wide, each... 75c.

Fig. 1 Fig. 2 Fig. 3

Fig. 1. Tool Steel Stone Wedges, per lb.........................$0.15
In ordering Stone Wedges, give size of steel and length of wedges wanted.
Fig. 2. Plugs and Feathers, 3½ inches long, ¾ hole, per doz. set........$1.10
" " " 4½ " " " " " " " 1.50
" " " 6 " " " " " " " 1.80
" " " 8 " " 1 " " " " 2.75
Plugs and Feathers from 10 to 46 in. long made for any size hole, per lb... .12
Fig. 3. Sandstone and Bedford Stone Plugs, per lb.................... .20

Larger Plugs and Feathers made to order.

BALL OR CHURN DRILLS

Drills, 7 feet long, each..............................$2.75
In ordering Drills give size of Bit wanted.

HAND DRILLS FOR STONE AND MARBLE

Hand Drills, per pound.....................$0.20

ROSE AND STAR DRILLS

These Drills made for Stone, Marble or Concrete.
Rose and Star Drills, per pound....................$0.25
Drills made for any size hole and length.

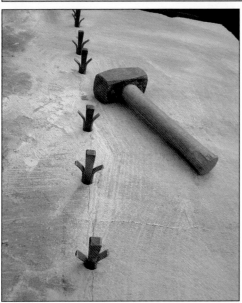

Before steam drills arrived, granite was split using plugs and feathers, as shown in this tool catalog from 1910 in the upper right corner. Small round holes were drilled three to six inches in depth and several inches apart. Two slips of iron called half rounds, or feathers, which are wedge shaped and rounded on the outside and thicker at the bottom, were inserted into each hole; a small steel wedge, or plug, is placed between the two half rounds. When all holes are thus supplied, a man went down the line of wedges, beginning at one end, and gave each wedge a smart blow with a hammer (using a 15- or 20-pound hammer). With the last blow, if not before, the entire mass is cleaved from the bedrock with a thin fissure reaching several times the depth of the holes. This method almost always provided a smooth straight separation. (Both, author's collection.)

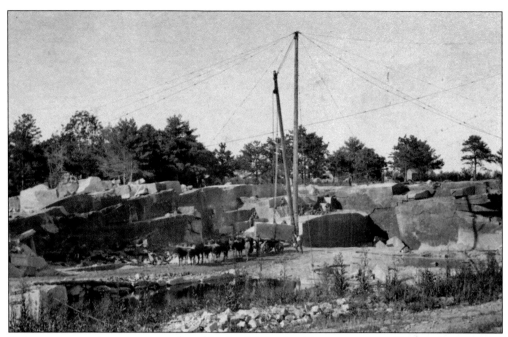

Before steam engines were introduced in the 1860s, derricks were powered by hand or teams of oxen. Made of wood, usually Douglas fir, they stood as high as 96 feet with a boom that reached 80 feet and was capable of lifting 40 tons. (SBHS.)

Cape Ann granite weighs 168 pounds per cubic foot, so quarrymen needed something strong and mobile to lift these heavy cuttings. They devised a system of blocks and tackle borrowed from sailing ships. It consisted of a vertical mast and a horizontal arm called a boom. This page from a late 19th-century sales catalog shows the basic makeup of a wooden derrick they offered. (Author's collection.)

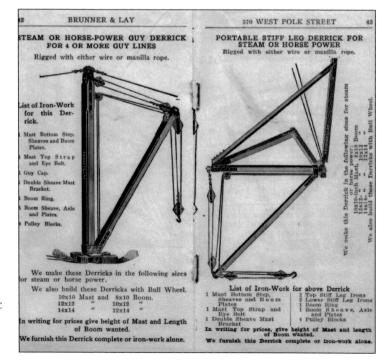

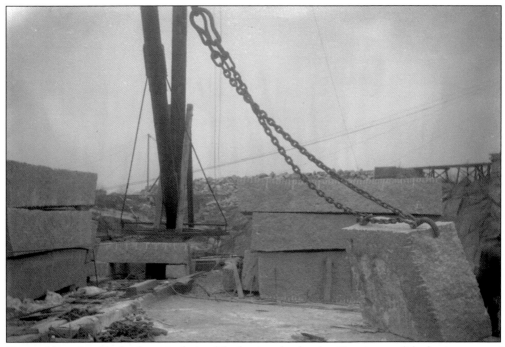

Pictured here is a block of granite being lifted using dog hooks. Granite was lifted using a set of iron hooks that operate similar to a pair of ice tongs. This derrick is lifting out of Blood Ledge Quarry. (SBHS.)

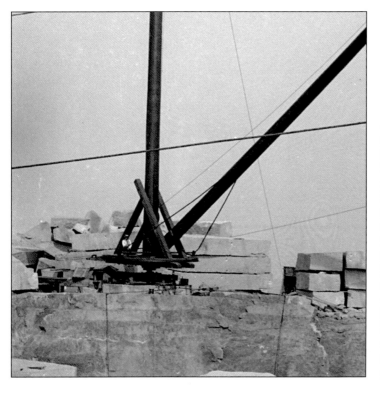

A derrick mast is mounted on a six-foot diameter steel bull wheel, which is mounted on an iron base called a kettle, allowing the derrick to be easily turned in any direction and the boom raised and lowered using a steam engine. This derrick was at Babson Farm Quarry in 1910. See how large the derrick mast is compared to the derrick operator next to it. (SBHS.)

Cape Ann Tool Company started as a small Pigeon Cove smithy, or blacksmith shop, for the quarries around Cape Ann in the 1850s. The many tools, hammers, chisels, steel bars, and other equipment needed was manufactured, sharpened, and repaired here. Looks like one of the workers commuted by bicycle. (SBHS.)

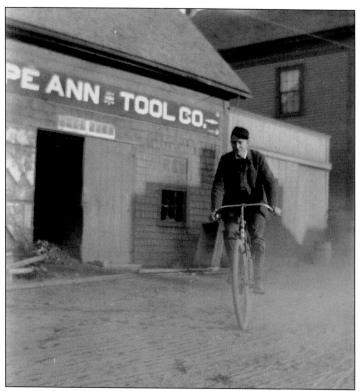

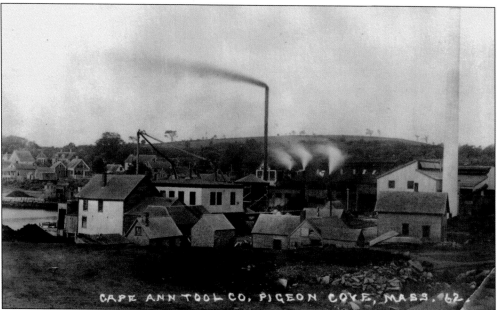

Although there were at least a dozen blacksmiths on the cape in the 1890s, a larger blacksmithing business was needed to handle the increasingly busy quarry trade. The Cape Ann Tool Company was started to fill that void on February 9, 1891, around the time the quarry railroad opened. The plant had six steam-powered forge hammers at that time. In later years, it featured a giant 100-ton drop-forge. (SBHS.)

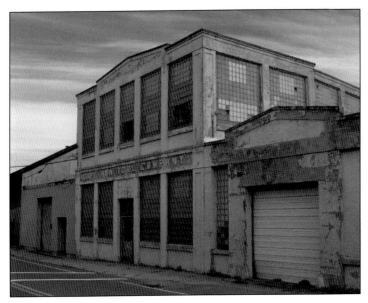

This is the Cape Ann Tool Company building in 1930. In later years, as the granite industry waned, it began to produce other metal parts for the automobile and aerospace industries. The parts of the Wright Whirlwind aircraft engine that powered the *Spirit of St. Louis*, flown by Charles Lindbergh across the Atlantic in 1927, were forged at the company. The company was shut down for good in 1987. (SBHS.)

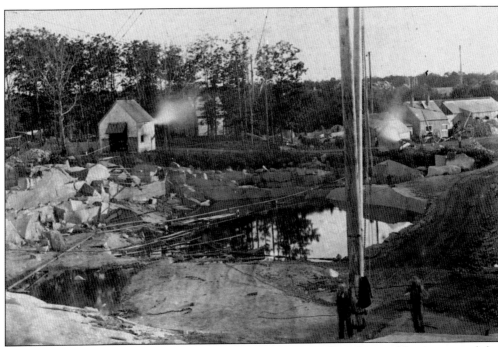

The quarry whistle (pictured above) was the primary signaling device, blasting out of the derrickman's shack on the quarry edge. Two long blasts indicated the powder man was about to shoot, and everyone stopped working and took cover. A long blast indicated an injury, and the ride box should be sent down immediately to ferry the injured man to the top. (SBHS.)

Around 1920, Dominic Toneatti operates a surfacing machine at Bay View's cutting shed for the Rockport Granite Company. Each surfacer knew exactly how their machine operated most effectively and always could tell how fast to move the pounding hammer to get the smoothest surface in the shortest time. Note *Polyphemus No.2* in the background. (CAM.)

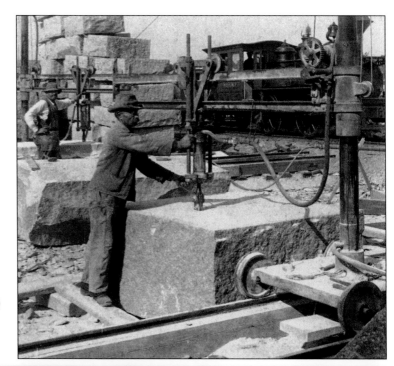

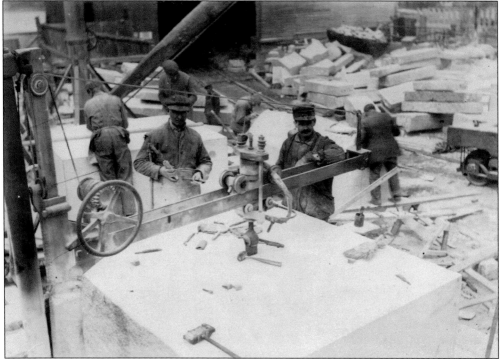

The surfacing machine at Bay View is set up with an air-powered bush hammer that the operator moved back and forth. Note the hand bush hammer in the foreground. A bush hammer had four to 10 chisel-like blades, or cuts, clamped together. The more cuts the hammer had, the smoother it would render the surface of the stone. (CAM.)

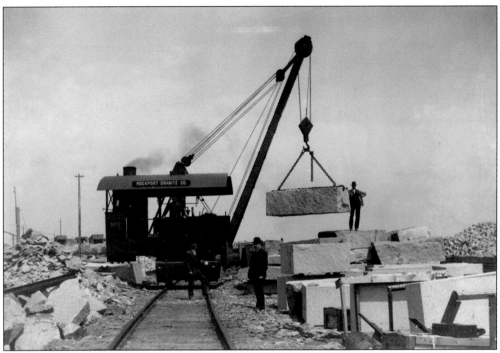

Locomotive cranes were first used at the Bay View works in 1909 by the Rockport Granite Company. They were steam-driven four-wheeled cranes run on the railway tracks and used in the cutting yard to load railcars. They had lifting beams that varied in size and use; this one is about 40 feet long lifting a 10-ton stone. They could lift up to 30 tons. (CAM.)

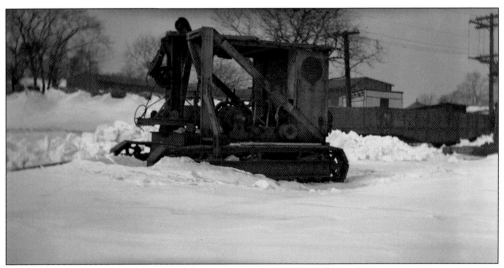

This is a motorized portable derrick winch engine, which could be driven anywhere within the quarry to power a derrick. The pulleys and sheaves hang from the front, and the power wheel winch unit is seen inside the cab. It was parked in the snow when most quarries closed for the winter. (CAM.)

Seven

THE STONE SHIPS

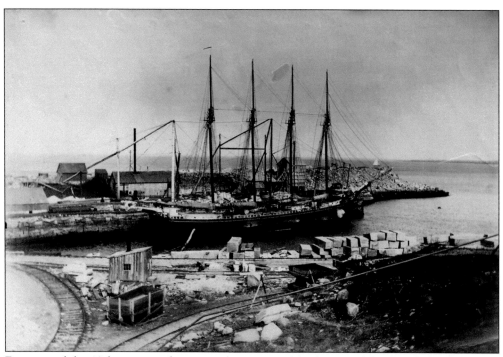

For most of the 19th century, there were five principal harbors used for shipping stone by the various granite companies. One at Hodgkins Cove in Bay View, others at Lane's Cove, Folly Cove, Pigeon Cove, Pigeon Hill wharf at Coburn's Point, and Granite Pier in Rockport. This four-masted schooner awaits a load of paving stones at Granite Pier. Note the railroad tracks that came down from Flat Ledge Quarry across Granite Street in Rockport. (SBHS.)

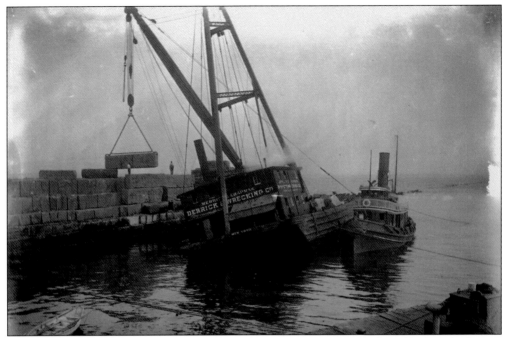

The tug *Confidence* assists the lighter *Commander* in placing 25-ton decking blocks, which were pinned with two-inch iron straps, on the breakwater. This lighter was leased from Merritt E. Chapman Wrecking Company of New York. The project was eventually abandoned in 1915, having deposited over two million tons of Rockport granite and with only 10 percent of the breakwater completed. (SBHS.)

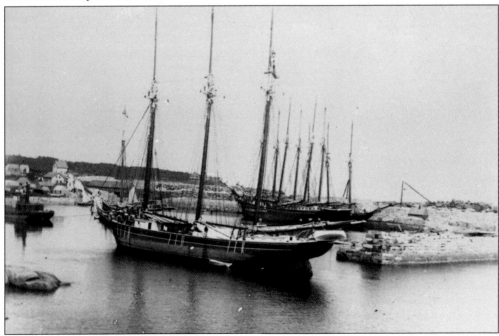

The three-masted granite ship *William D. May* from Philadelphia is arriving in Pigeon Cove to pick up paving stones for its city streets. This ship could hold 50,000 paving stones. (SBHS.)

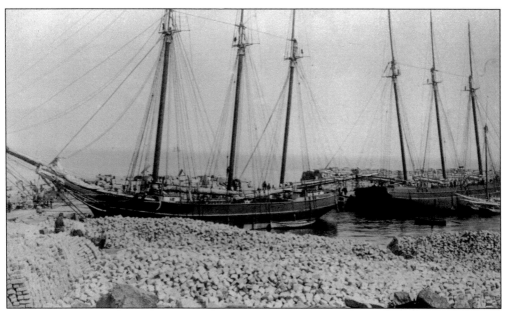

These three-masted schooners are loading paving stones at Lanes Cove; note the opening of the breakwater between the two ships. The vessel on the left is the *Frank Leaming*, and the other is unidentified. In one month, 31 schooners averaging 200 tons each sailed from Lanesville loaded with paving stones. (SBHS.)

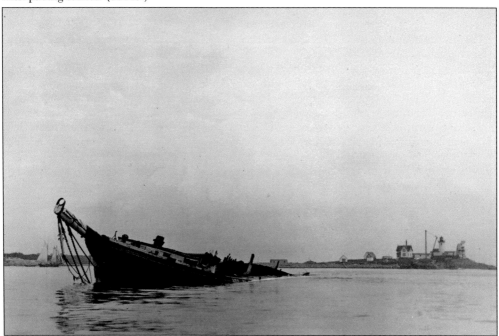

During its construction, Dog Bar breakwater in Gloucester Harbor constituted an unchartered reef. Capt. H.M. Godfrey of the schooner *Eleanora Van Dusen* discovered this when he tried to make safe harbor the evening of September 19, 1900. Sailing from Bay View loaded with 23,000 paving blocks and 82 tons of rough granite, Godfrey ducked into the harbor because of the weather and met disaster. She was the 27th vessel to strike the breakwater. (CAM.)

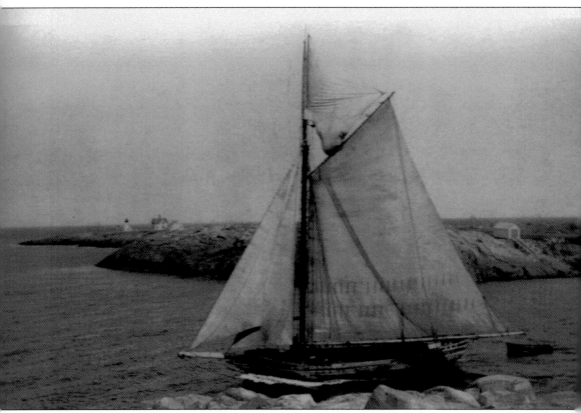

The stone sloop *Albert Baldwin* is going through the gap near Straitsmouth Island on the way to pick up granite at Pigeon Cove in Rockport in 1925. She was skippered by William Howard Poland of Gloucester and built in Essex, Massachusetts, at the Tarr & James Yard in 1890. Col. Jonas H. French owned her and named it for a friend of his. She was 123 gross tons, 86 feet long, and carried a crew of six men. This was the largest stone sloop ever built in this vicinity and had the largest mainsail, over 1,100 square yards, of any sloop of its time. Its main mast was 90 feet tall, and the top mast was 43 feet long. The main boom was 82 feet. It was built with three-inch planking able to carry 200 tons; at times her deck was often awash when fully loaded. She was known as the "Floating Ledge." In 1934, she was abandoned at Smith Cove in East Gloucester and dismantled by a Works Progress Administration (WPA) crew. She was the last of the famous Cape Ann granite sloops. (SBHS.)

Capt. William H. Poland was the only skipper that the *Albert Baldwin* ever had, serving from 1890 until 1920. He had helped in her design. Poland also skippered the schooner *J.M. Todd*, the sloop *Daniel Webster*, and the sloop *William P. Hunt* for eight years. Captain Poland remained as master until World War I, and he was 91 when he died in 1940. (CAM.)

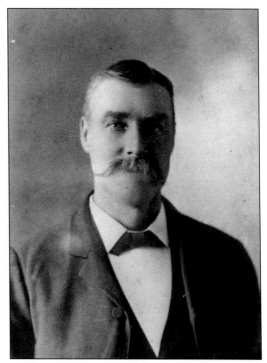

The stone barges were of extra-heavy construction, usually oak timbered and planked, broad beamed, and staunchly rigged. They were single stick (one mast) and had a gaff-rigged mainsail. Each carried a sturdy cargo boom, stepped into a saddle or block on deck at the foot of the mast. This was used to swing cartloads of paving stone or lower dimension stone into its hold. (SBHS.)

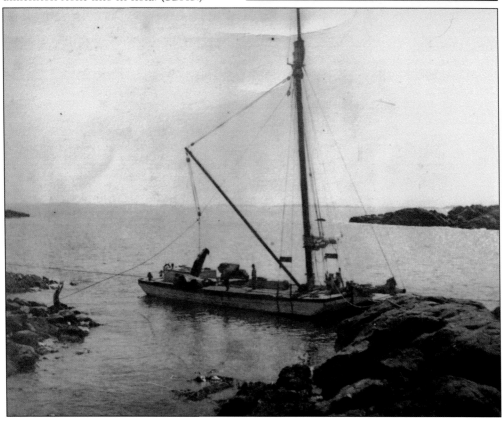

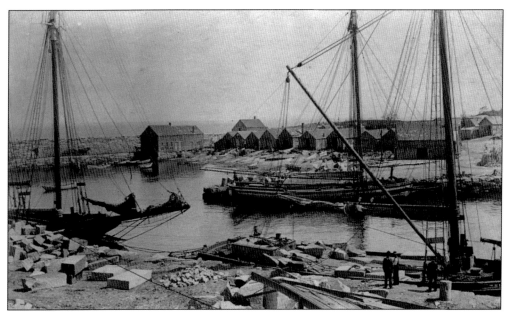

Lanes Cove is pictured here, with fish shacks on the far shore. The sloops *Albert Baldwin* on the left and the *Whip* on the lower right are ready for their cargoes to be loaded. Fishermen and quarrymen shared Lanes Cove over the years. (SBHS.)

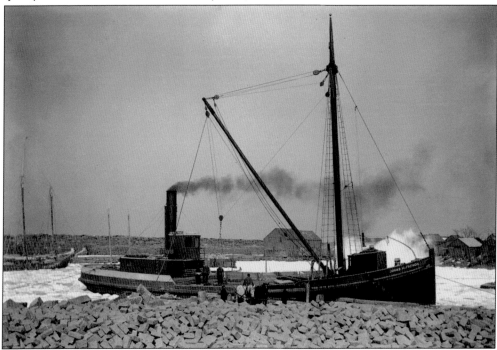

Stone carrier *Jonas H. French* is trapped in winter ice in Lanes Cove. Granite sloops plied the waters around Cape Ann all the way to New York, New Orleans, and the Caribbean. Cape Ann Granite Company was the largest supplier of paving stones in the nation. The industry lasted until the 1930s, when the call for granite paving blocks was reduced when asphalt and cement roadways became the norm. (CAM.)

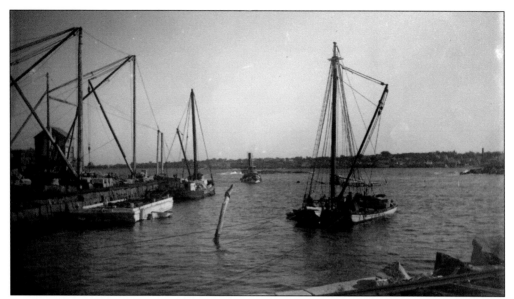

In the center is the granite scow *Jumbo* arriving at Pigeon Cove dock to haul and load stone to build the Sandy Bay breakwater. The Rockport Granite Company owned two scows in 1892. The tug seen in the center is the *Confidence* on its way to pick up the scow on the left. The lighter ahead of the scow was home ported in Portsmouth, New Hampshire. (SBHS.)

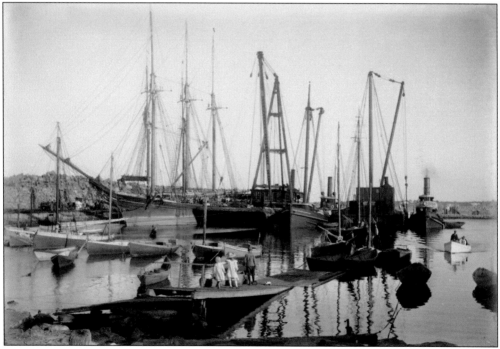

The float in the foreground was used for visiting officers from battleships, which came to Rockport every summer from 1898 to 1919. From left to right are the four-masted granite schooner *General Adelbert Ames*, the derrick barge *Commander*, the rock ship *William H. Moody*, tug *Confidence*, an unidentified lighter, and the tugboat *H.S. Nichols*. The children on the dock are awaiting a ride in the arriving motor launch. (SBHS.)

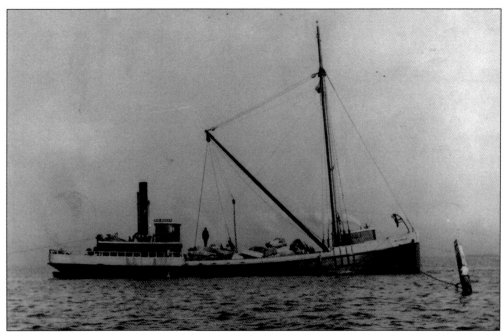

This is the steam "rock" ship *William H. Moody* tied up to a mooring near Granite Pier in Rockport. Her boom line is ready to unload stone, probably for the Sandy Bay National Harbor of Refuge breakwater. Her steam donkey engine near the bow is smoking, meaning that she is ready to lift the load of stone. (SBHS.)

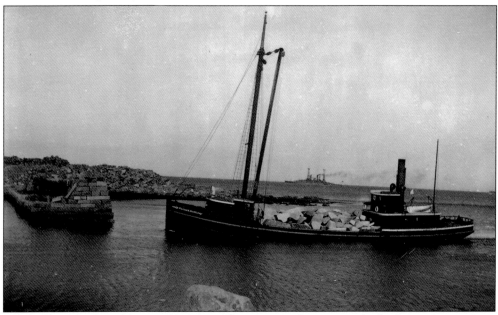

This is an interesting photograph of the *William H. Moody* entering the harbor at Pigeon Cove with a load of grout. Note the battleship in the center distance steaming north. This was one of the North Atlantic Fleet's vessels that came to Rockport each summer for naval exercises. They came to publicize and encourage the building of the 5,000-ship Sandy Bay National Harbor of Refuge breakwater. (SBHS.)

The steamer *William H. Moody* sidles up to a Rockport Granite Company self-dumping scow while building the Sandy Bay breakwater. The *Moody* was built in Essex in 1898 and rated at 259 gross tons. The company reported in 1930 that it owned two barges, *R.G. Scow No. 1* and *Herbert*; it is unknown which one this is. (SBHS.)

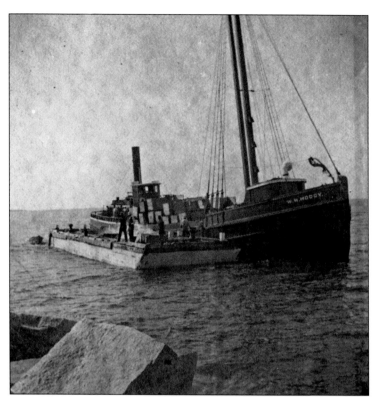

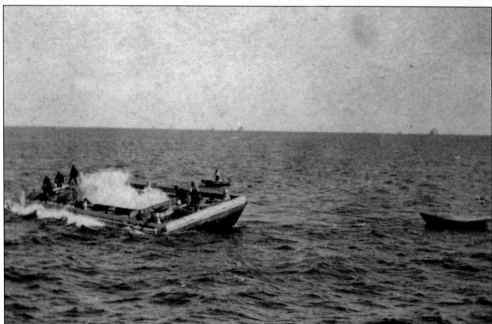

A self-dumping scow is pictured here in action on the Sandy Bay breakwater in September 1891. The scow had drop down hinged doors in its floor to release the grout to build up the breakwater base. Note the marker buoy in the center that marks the exact location of the unloading point. The man in the skiff is directing operations. (CAM.)

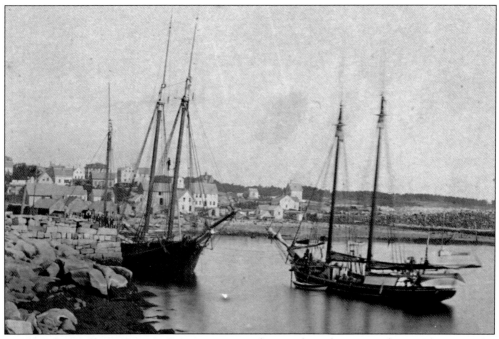

In 1864, the Rockport Granite Company reported ownership of six stone sloops. They were the *Belle of Cape Ann, Cock of the Walk, Ida May, Bracelet, New Era,* and *Arcadia,* all of which were valued at $23,500. On July 13, 1865, the company reported delivering 1,293 tons of foundation stone to the Portsmouth Navy Yard in New Hampshire via these sloops over 13 deliveries, at a cost of $2.88 per ton of granite. (SBHS.)

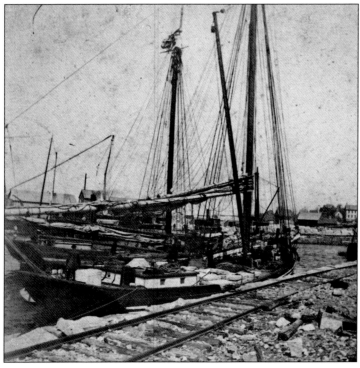

The schooner *America,* tied up in Pigeon Cove, was built in Salisbury, Massachusetts, in 1889, captained by Jeremiah Pettingill and owned by the Rockport Granite Company. She was actively hauling stone for the company from 1892 to 1898. (SBHS.)

Charles E. Schmidt of Bridgeton, Maine, and the *Gatherer* are both stranded on Knowlton's Point in Rockport on November 11, 1891. A local newspaper story about stone sloops reported, "Loaded to the water's edge, with cargo that is almost impossible to throw over in a storm, they are liable to sink in a squall, as they are loaded to deep to upset." The *Gatherer* was built in Essex in 1876. (SBHS.)

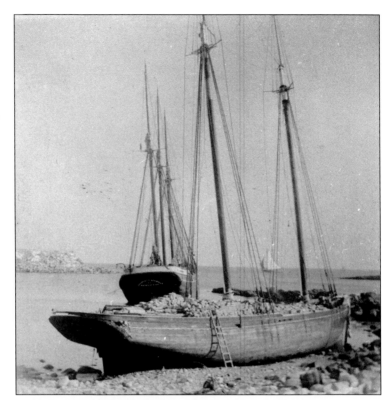

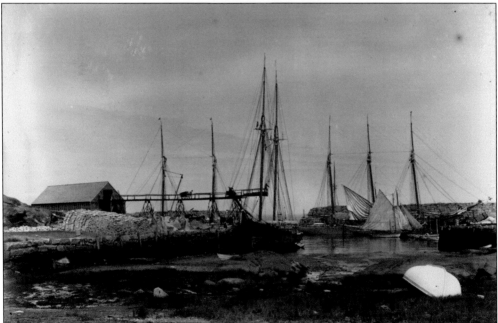

The *James A. Gray* is loading at Lanes Cove at low tide, and a unique loading arrangement was employed here. On the suspended ramp a man can be seen pulling a cart load of paving stones. A 25-foot wooden chute was lowered from the end of the ramp, and the stones were tumbled into the ship. Across the harbor is the *Albert Baldwin*, just behind the fishing shack. (CAM.)

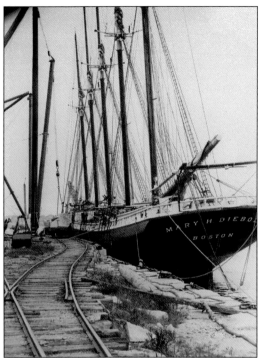

The *Mary H. Diebold* of Boston, a five-masted schooner, is loading rip-rap at Granite Pier in 1928. Rip-rap was made up of scraps of unusable granite often used for breakwaters. Cape Ann granite was used for breakwaters at the Isle of Shoals, the entrance to the Cape Cod Canal, Point Judith, Rhode Island, jetties at Mayport and Key West, Florida, and Coney Island, New York. (CAM.)

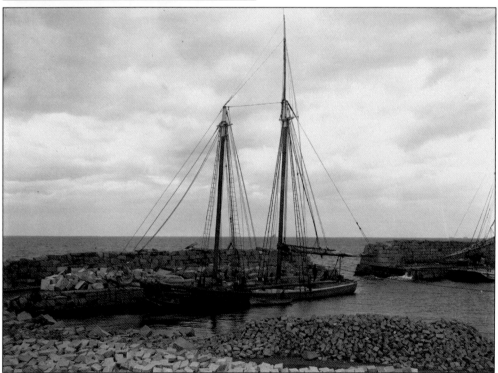

The schooner *Mary Steele* out of Boston awaits her cargo. The entrance to Lanes Cove was very narrow, and large schooners like this had to be towed out and warped through the 52-foot entry by small rowboats before sails could be set. (CAM.)

Multnomah is loading granite at Lanes Cove around 1910. The *Multnomah* was 82.5 feet long, 124 gross tons, and built in Ledyard, Connecticut, in 1889. The pride of the Cheves Green Granite Company was wrecked on Saturday, June 18, 1910, in a heavy fog bound for Lanes Cove to pick up grout for the Cape Cod Canal when she stove in her bottom rounding Eastern Point in Gloucester. (CAM.)

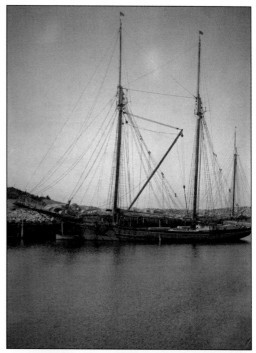

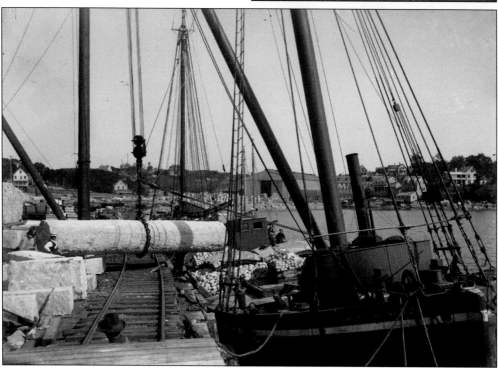

Here at the Rockport Granite Company's Bay View wharf, a 16-ton rough-cut column is loaded with paving stones on the company lighter *R.G.Co No.1* in 1917. This shipment was headed to East Boston, and from there it traveled by train to its destination. Many times, custom items like this were delivered in the rough and finished on the job. (CAM.)

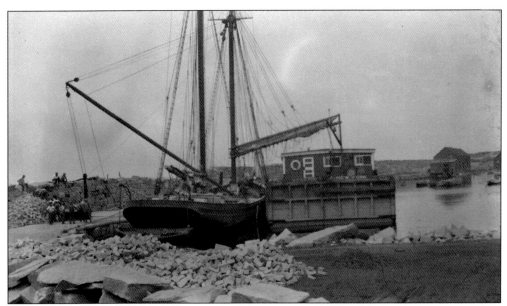

The *George R. Bradford* in Lanes Cove is loading. Note the lifting hoist that is stepped to the mainmast on the left and is ready to lift. The boom to the main sail is pulled out of the way to the right. The *Bradford* was named for one of the partners in the Eames, Stimson Granite Company. The lighter *Sagamore* from New York is next to her. (CAM.)

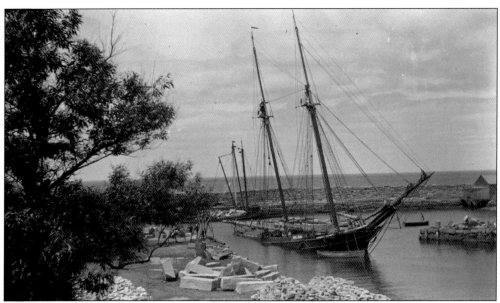

Schooner *William H. Wood* is sinking at Lanes Cove. It is unclear if the load was too heavy, the load shifted, or they had stove in the hull on the treacherous rocks around Cape Ann. (CAM.)

Eight

THE FINAL PRODUCT

The Boston Post Office cornerstone was laid on October 16, 1871. Unfortunately, the great Boston fire of November 1872 burned the new post office so badly it had to be rebuilt in 1875. Both used Cape Ann granite from Old Pit Quarry in Lanesville. By December 1929, this classic old building was razed and a new one constructed in 1931. (SBHS.)

The Boston Custom House clock tower was built in 1915 using gray Rockport granite. This 500-foot tower was Boston's first skyscraper. The tower was added to the original base, which was constructed in 1837 and is of Quincy gray granite. Note the eagles on each corner of the base of the clock tower. (SBHS.)

Four 16-foot 50-ton granite eagles were carved in Rockport to adorn the tower on the Boston Custom House. The granite came from Flat Ledge pit in Rockport for two of the eagles and from Old Pit in Bay View for the other two. Each was made of 11 blocks and took 15 men a month to build just one. The four were completed in 1915. (CAM.)

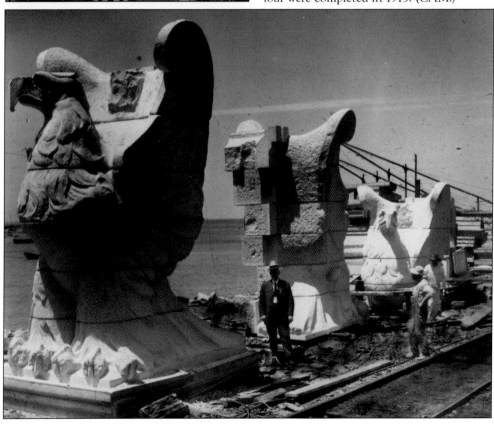

This 14-foot granite statue of Pilgrim captain Myles Standish was created at the Bay View finishing shed by the Cape Ann Granite Company using pink-hued granite obtained from their Wass Quarry in Maine. It was S.J. O'Kelly of Boston who molded the heroic figure from a five-foot-tall plaster-cast model, and the monument was cut by Stefano Brignoli and Luigi Limonetta of Bayeno, Italy. (CAM.)

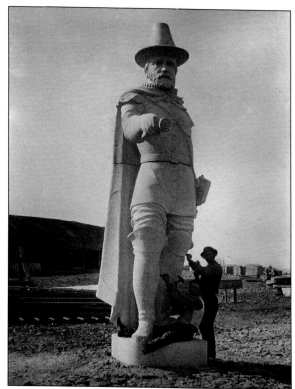

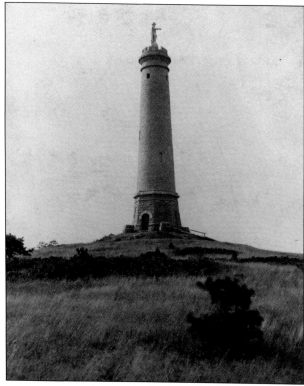

The commanding figure of the Pilgrim captain holds the charter of Plymouth Colony as he looks across Cape Cod to the east. This statue stands atop a 116-foot granite shaft. The cornerstone was laid in October 1872 and finally completed 26 years later in 1898. The monument stands on the crest of Captains Hill at the Standish Monument Reservation in Duxbury, Massachusetts. (SBHS.)

Philadelphia City Hall was erected between 1810 and 1901. Using granite supplied by the Cape Ann Granite Company of Bay View, the building covered 4.5 acres, contained 634 rooms, and rose 548 feet above street level. A huge bronze statue of William Penn crowns the tower. Inside, Cape Ann granite was used in the five-story spiral hanging stairway, which seems to have no visible means of support. (SBHS.)

In December 1915, workers lay paving stones on Broad Street in Elizabeth, New Jersey. Paving stones were shipped by Rockport Granite Company as far as Cuba and Valparaiso, Chile. Cape Ann paving stones were represented in the largest cities and towns throughout the United States. Paving stones are typically either set in sand or similar material or are bound together with mortar. (SBHS.)

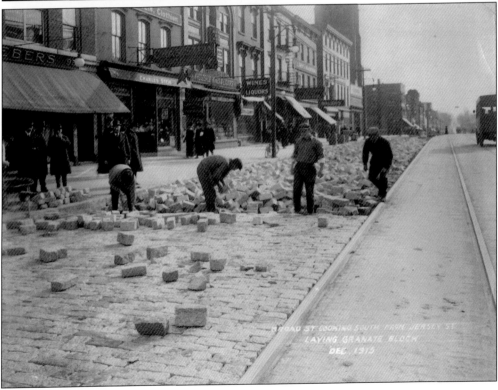

Pictured here is one of two polished sea-green granite fountains in Union Square Plaza, Washington, DC, near Union Station. It was quarried, shaped, and polished by the Rockport Granite Company in Bay View. It was cut from a single piece of granite that came from Blood Ledge Quarry and weighed 65 tons, measuring 13 feet wide and 11 feet tall, and the diameter of base was 22 feet, six inches. (SBHS.)

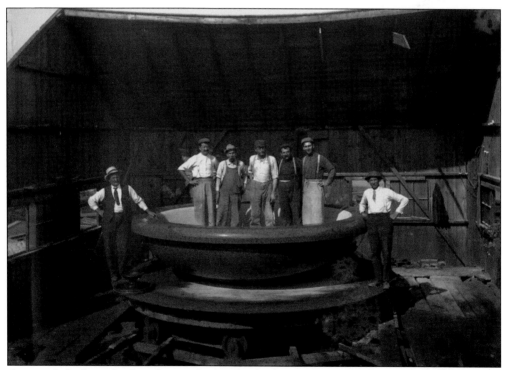

A special shed was built to house the bowl, which was mounted on a revolving platform in the Bay View stone yard. Much of the shaping and cutting was done by hand, and the first bowl was completed in July 1910. Workers are standing inside to demonstrate its size. On the floor to the left is a wooden scale model of the bowl now exhibited at the Sandy Bay Historical Museum. (SBHS.)

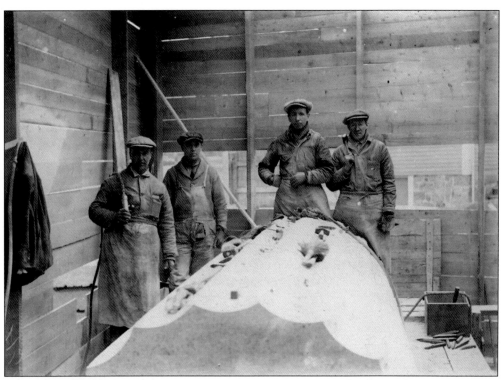

In 1922, Rockport Granite Company employees at their cutting sheds at Granite Pier are working on the column fluting for the Mellon National Bank in Pittsburgh, Pennsylvania. From left to right are cutters Tom Tassell, Bill Jewell, Bill Gray, and George Gray. The entire exterior of the bank was faced with Rockport gray granite. (CAM.)

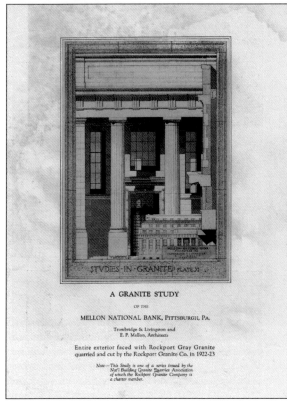

A GRANITE STUDY

OF THE

MELLON NATIONAL BANK, PITTSBURGH, PA.

Trowbridge & Livingston and
E. P. Mellon, Architects

Entire exterior faced with Rockport Gray Granite
quarried and cut by the Rockport Granite Co. in 1922-23

Note—This Study is one of a series issued by the
Nat'l Building Granite Quarries Association
of which the Rockport Granite Company is
a charter member.

This is an illustration, part of a series of sales sheets issued by the National Building Granite Quarries Association of which Rockport Granite Company was a charter member. It highlights the design used in the Mellon bank building and shows the fluted columns in front of the bank. (SBHS.)

Providence World War I Memorial used Moose-A-Bec red granite supplied by the Rockport Granite Company. It stands 115 feet high and 11 feet in diameter with a 23-ton base stone. The monument is composed of 595 masonry blocks or roughly 16,000 cubic feet of fluted granite. On January 8, 1929, the finished 23-ton granite statue *Victory* was raised to the top of the fluted shaft. (SBHS.)

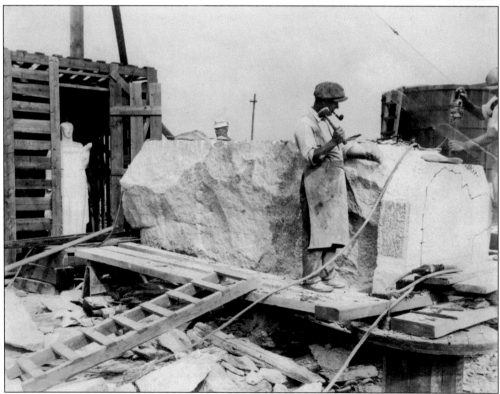

The 15-foot tall statue of the *Victory* figure was rough carved from a 65-ton block by stone carver George Ricker along with William Jewell and Angelo Buzzi. It was set on sleepers under a canopy for weather protection. It was dedicated on Armistice Day on November 11, 1929. See the scale model furnished by the sculptor C.P. Jennewein in the shed. (CAM.)

Bay View was stacked high with blocks of granite destined for the lighthouse at Graves Ledge in Boston Harbor. The first stones were landed on the ledge aboard the steam lighter *Ben Harrison* on August 11, 1903. The lowest course of stone, 30 feet in diameter, was laid just four feet above the low-tide mark. By July 1, 1904, the workers completed 44 courses and the lighthouse rose to a height of 88 feet above the ledge. The ironwork was done in Boston, and the second-order Fresnel lens was built in Paris, France. A granite oil house was constructed south of the tower with a footbridge connecting it to the lighthouse. On the evening of September 1, 1905, the keeper climbed the circular ladder and turned on the light in the lantern room for the first time. A powerful 380,000-candlepower beam illuminated the harbor, and at the time it was the most powerful light in Massachusetts. It was a double white flash appearing every six seconds. (US Coast Guard Historian Office.)

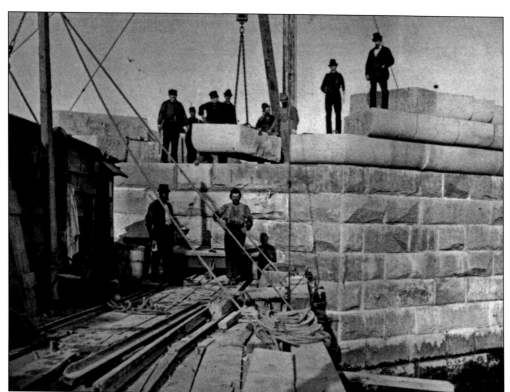

James Edmunds and Gustavus Lane, owners of the Bay State Quarry, had the contract to furnish 12-ton blocks for the foundation of Race Rock Lighthouse on Long Island Sound, eight miles off New London, Connecticut. Their most experienced stonecutters worked on the contract, and the finished blocks were fit together perfectly when lowered into place underwater at the ledge. The Cape Ann sloop *Screamer* was used to deliver the stone to the lighthouse and made several trips. The *Screamer* was built in 1873 and assisted the steamer *Enterprise*, which carried 19 huge blocks, each one as big as two pianos. These blocks formed the top two layers, which surrounded the lighthouse. The lighthouse station was completed seven years later on New Year's Day 1879, when the light was first lit. (Above, US Lighthouse Society; right, US Coast Guard Historian's Office.)

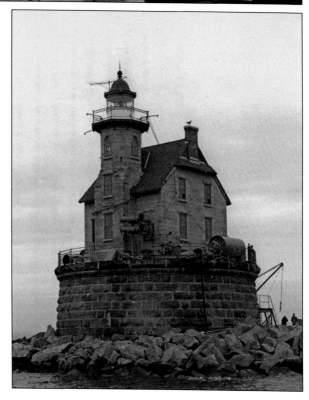

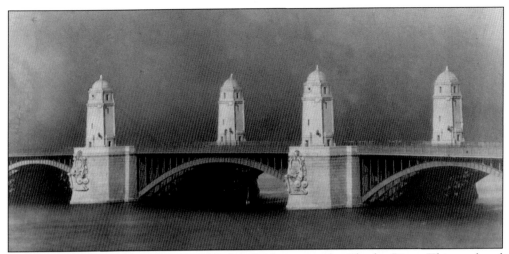

Longfellow Bridge connects Boston with Cambridge across the Charles River. This steel and granite structure was completed in 1908 and renamed to honor Henry Wadsworth Longfellow in 1927. The four piers are ornamented with the prows of Viking ships carved in the granite. They refer to a voyage by Leif Eriksson up the Charles River around 1000 BCE. The granite used here came from Deep Pit Quarry (later Old Pit) in Bay View. (CAM.)

In Norfolk, Virginia, the US Navy Shipyard Dry Dock No. 4 was built using Cape Ann granite and opened on April 1, 1919. Located on the Elizabeth River, it is the oldest dry dock in the nation. A US Navy battleship in the accompanying photograph may be the USS *North Carolina* (BB52), whose keel was laid there in January 1920. (SBHS.)

Nine

GRANITE ON CAPE ANN

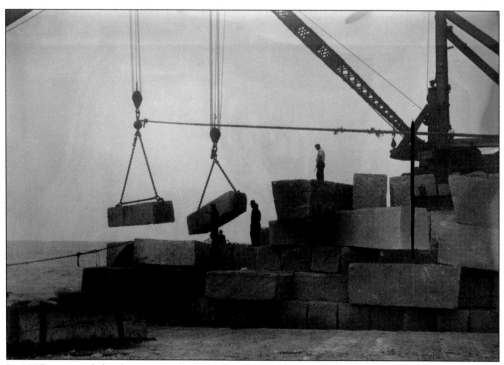

In 1885, a giant federal project called the Sandy Bay National Harbor of Refuge breakwater was started in Rockport. It was to provide a safe harbor in storms and be used as a base for naval exercises held by the North Atlantic Fleet. At the time, it was estimated that 70,000 vessels passed by Cape Ann annually. (SBHS.)

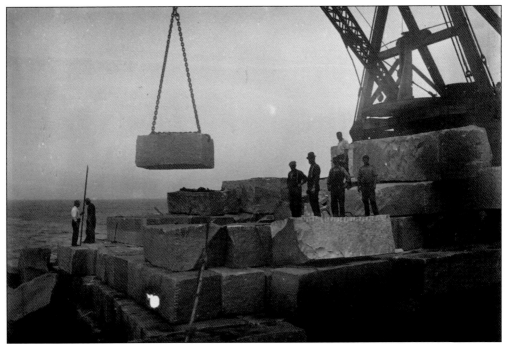

Here, a barge derrick lifts granite blocks weighing more than 30 tons each onto the breakwater. It was originally estimated to need over one million tons of granite to complete. Cost estimates had escalated from $5 million to over $6 million since its start in 1885. By 1916, barges placed over 2,133,734 tons of granite at a cost of $1,941,479. (SBHS.)

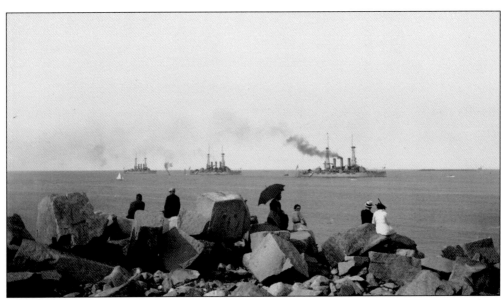

Sightseers are viewing the arrival of the North Atlantic Fleet in 1910. That year, 32 ships anchored in Sandy Bay to demonstrate the need and positive aspects of building the Sandy Bay National Harbor of Refuge. Far in the distance to the right the breakwater construction can be seen. (SBHS.)

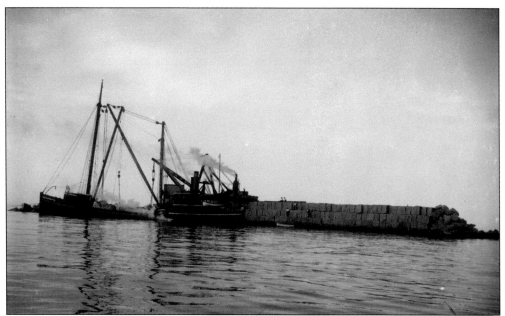

A lifting scow and granite sloop are constructing the breakwater in 1900. It was to consist of a granite-block V-shaped wall extending one mile northwest toward Andrews Point and southerly about three quarters of a mile towards Thacher Island and Avery's Ledge. The harbor would enclose 1,664 acres and was estimated to hold 5,500 ships. It would be situated in an area where over 147 total wrecks and 560 partial disasters occurred between 1874 and 1894. (SBHS.)

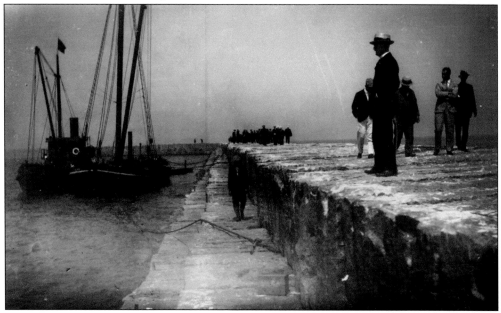

In 1915, federal inspectors recommended the breakwater not be completed, stating in their report, "The net result of the reexamination was that the benefits to be derived from completing this harbor of refuge were not sufficient since coastal steamers were replacing schooners in these waters." Of the originally planned 9,000-foot breakwater, only 922 feet had been completed by 1916. The project was officially abandoned in 1917. (SBHS.)

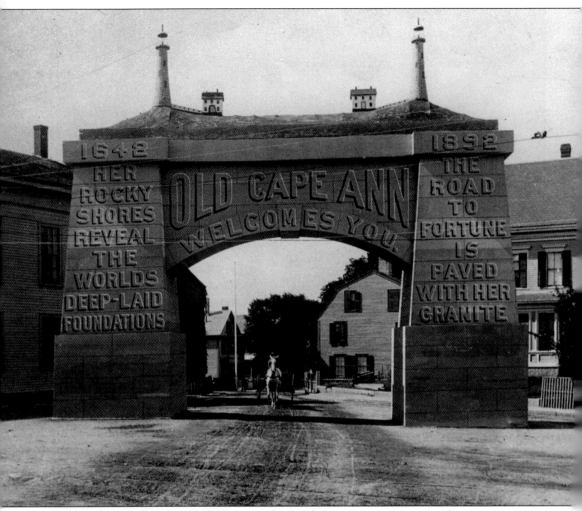

In August 1892, the City of Gloucester celebrated the 250th anniversary of its incorporation. This memorial arch was created at the entrance to the city on Middle Street in Town Hall Square. This memorial was built to highlight the importance that granite played in the city's economy at the time. The inscription "Old Cape Ann welcomes you, her rocky shores reveal the worlds deep-laid foundations, the road to fortune is paved with her granite" said it all. Although this arch was made of wood covered in cloth, it was meant to represent the solid masonry with imitations of granite blocks. The arch stood 48 feet wide and 24 feet high. It was large enough to allow wagons and horses to pass through. The monument was surmounted by reproductions of the twin lights of Thacher Island, which were illuminated by incandescent electric lights 40 feet above the street. (CAM.)

A breakwater was built from 1894 through 1905 at the entrance to Gloucester Harbor that extended from the Eastern Point lighthouse to mark the Dog Bar reef. It is 2,250 feet long, seven feet wide, and cost $300,000. The substructure of the breakwater is a rubble mound, which was covered with 231,756 tons of Cape Ann granite blocks each weighing 12 to 13 tons. Three companies supplied the granite—Rockport, Cape Ann, and Pigeon Hill Granite Companies. (CAM.)

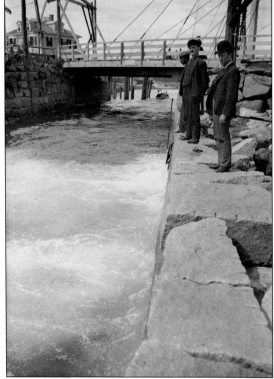

The Blynman Canal, which separates Cape Ann from the rest of the North Shore, is shown here in 1905. The Annisquam River runs from Ipswich Bay and through the canal emptying into Gloucester Harbor. The canal was lined with Cape Ann granite in the mid-1800s from the Wolf Hill Granite Company quarry just north of the canal. This swing bridge was replaced by a modern drawbridge in 1910. (CAM.)

The first granite products produced on Cape Ann were millstones and mooring stones. A hole about 15 inches in diameter was cut though the center of a large piece of granite usually six feet square and eight to 16 inches thick. An uprooted white oak tree was cut, and the 20-foot tree trunk stuck through the hole; the root ball prevented it from slipping through. (Author's collection.)

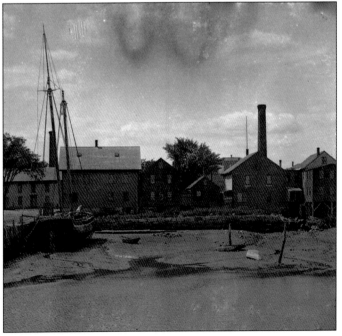

The entire mooring stone unit was rafted out and sunk to the harbor bottom, and mooring lines were tied to the 20-foot tree-stump mooring mast. The oak lasted for years, and the stone never moved even during storms. This is the old harbor in Rockport. Joshua Norwood of Rockport made the first mooring stones and had produced more than 40 by 1710. (SBHS.)

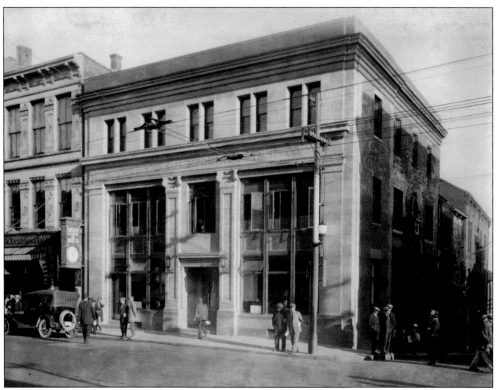

Built in 1919, the Gloucester Safe Deposit and Trust Company still stands today at the corner of Main and Pleasant Streets. It was faced with Moose-A-Bec red granite in a ribbed finish. It was described by the company as "biotite granite, of generally dark reddish color, with pinkish and white feldspars, on a background of smoky quartz. It texture is coarse, even-grained . . . the granite takes on a fine polish." (SBHS.)

The Granite Savings Bank on Main Street in Rockport was incorporated on March 21, 1884, and the first deposit was made on April 11, 1885. Frank Scripture was one of the original incorporators as well as one of the owners of the Pigeon Hill Granite Company from which this granite was harvested. Today, it is the Toad Hall Bookstore and has not materially changed in appearance since its completion in 1926. (SBHS.)

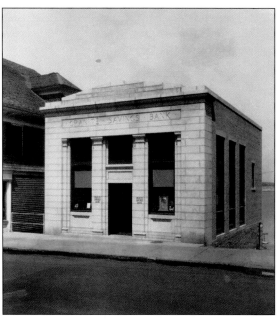

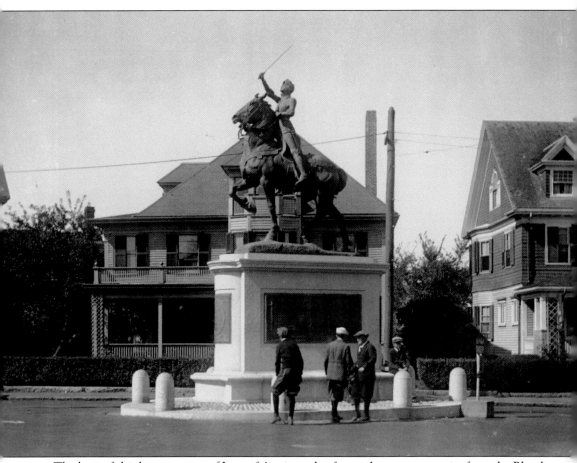

The base of this bronze statue of Joan of Arc is made of carved sea-green granite from the Blood Ledge Quarry in Lanesville. It stands in Legion Square in Gloucester facing the local Capt. Lester S. Wass American Legion Post No. 3 on Washington Street. There are bronze plaques on either side listing the "Sons of Gloucester Who Gave Their Lives in the Great World War." Wrapping around the base is a granite bench, and there are beach stones surrounding the monument, set into the ground like cobblestones. Designed by Anna Hyatt Huntington (1876–1973), her original Joan of Arc statue won an honorable mention at a Paris art show. There are four other statues cast by her, one each in New York City; San Francisco; Quebec, Canada; and Blois, France. She made the original plaster cast in her family's studio in 1910, which was in Annisquam. It has been reported that the horse was modeled after one of the East Gloucester Fire Station's horses, and the Joan model was actually Anna's niece, sitting on a barrel. The sculpture was dedicated in 1921. (CAM.)

The Carnegie Public Library was built using seam-face granite from the Rockport Granite Company. This variety of granite is of rustic coloring, running from gray and light, warm browns to deep, rich, rusty reddish browns, and adapts well for use both in walls and buildings. This granite was sometimes referred to as sap-face or ashlar granite because of its reddish-brown color bleeding through it. This was a fine example of the use of both the gray and brown granite for the library. This building still stands and was converted to a private residence. Many other buildings in Rockport used this seam-face stone—the fire station, post office, and parts of the original town hall. The Town of Rockport voted on November 11, 1903, to accept Andrew Carnegie's $10,000 gift to build this library; the cornerstone was laid on December 3, 1904; and the institution opened on February 3, 1906. Andrew Carnegie, businessman, steel magnate, and philanthropist, built 1,689 libraries in the United States from 1901 to 1917, spending more than $45 million. (SBHS.)

Here are the ruins of the Annisquam Steam Cotton Mills in Rockport, pictured on June 22, 1884. The mill was built in 1847 using Rockport Granite Company stone, and it covered two blocks on Broadway in Rockport near Dock Square, including two towers with a tall smokestack adjoining. It burned down on December 9, 1883. One structure, the machine shop and engineering department (building at lower right side in the image below), was saved and restored as the George J. Tarr School in 1904 and eventually revamped to become the current Rockport Public Library. Across the street from the mill were four company houses erected as quarters for the mill workers, still serving as residences today. The mill employed 240 workers who made cotton duck cloth for sails as well as yarn sold to fishing-line manufacturers. This view was taken from the top of the Congregational church steeple. The ruins remained there for 22 years until the school begin operation in 1904. (Both, SBHS.)

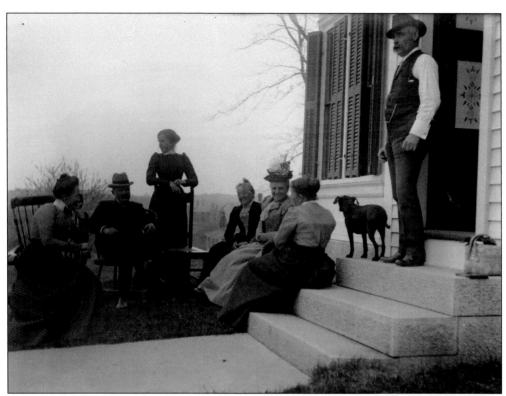

These are typical dressed-granite steps used around Cape Ann. The steps are rough finished but have smoothed edges to give them a decorative yet nonslip walking surface. There are three large blocks set on one large piece for the bottom step, which supports the top three blocks. This photograph was taken by Charles Cleaves at his grandfather's house in 1895. (SBHS.)

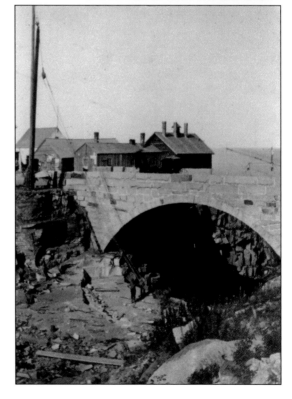

The Keystone Bridge had just been completed in 1872, but it had not been fully opened through to Granite Pier from the quarry side. The rough stone piles can be seen under the arch, and the Rockport Granite Company office had not yet been constructed, which would be placed where the small rectangular building with the single chimney is located. (SBHS.)

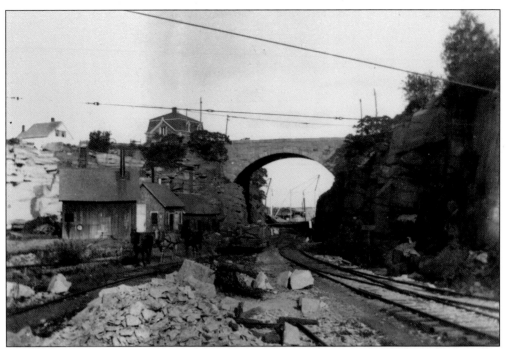

The Keystone Bridge from the Flat Ledge Quarry side looking toward the harbor at Granite Pier is seen here. The Rockport Granite Company office is at the top; it was completed in 1892. Three horses are pulling a railcar back to the quarry with its driver sitting on the car. (SBHS.)

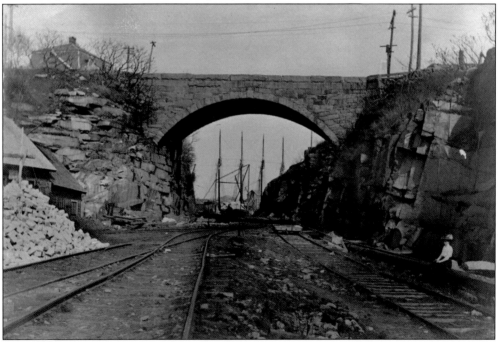

Very seldom is a woman seen in any quarry scenes. Here is one who may be the wife of the photographer, Charles Cleaves. She sits on one of the derrick masts inside the Flat Ledge Quarry. (SBHS.)

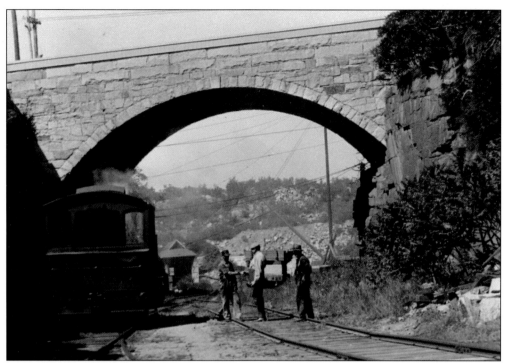

The archway opening has been completed, and railroad tracks were added about 1887. The rear of the locomotive *Nella* is shown heading back into the quarry, and the train engineer is shaking hands with one of the foremen. (SBHS.)

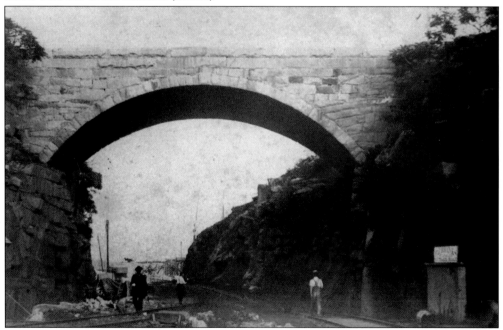

The train scale is mounted in the box on the right-hand side with a sign that reads, "F.M. Brinks standard R.R. Track Scale." The loaded train cars were weighed here on their way to the shipping wharf. (SBHS.)

BIBLIOGRAPHY

Cooley, John. *A Blacksmith Shop Grows Up: The Story of the Cape Ann Tool Company.* Pigeon Cove, MA: 75th Anniversary of Cape Ann Tool Company, revised edition 1975.

Babson, John J. *History of the Town of Gloucester, Cape Ann.* Gloucester, MA: Proctor Bros., 1860.

Brayley, Arthur W. *History of the Granite Industry of New England.* Boston, MA: National Association of Granite Industries of the United States, 1913.

Carlotto, Mark J. *The Island Woods: Abandoned Settlements, Granite Quarries, and Enigmatic Boulders of Cape Ann, Massachusetts.* Lexington, KY: self-published, 2012.

Cooley, John. *The Granite of Cape Ann.* Rockport, MA: Rockport National Bank, 1974.

Copeland, Melvin T., and Elliot C. Rogers. *The Saga of Cape Ann.* Freeport, ME: Bond Wheelwright Co., 1960.

Chamberlain, Allen: *Pigeon Cove, Its early Settlers, Their Farms, 1702–1840.* Pigeon Cove, MA: Village Improvement Society of Pigeon Cove, Inc., 1940.

Dennen, W.H. *The Rocks of Cape Ann.* Gloucester, MA: Gloucester Cultural Commission, 1992.

Erkkila, Barbara H. *Hammers on Stone: A History of Cape Ann Granite.* Woolwich, ME: TBW Books, 1980.

———. *Village at Lane's Cove.* Gloucester, MA: Ten Pound Island Book Co., 1989.

Gott, Lemuel. *History of the Town of Rockport.* Rockport, MA: Rockport Review Office, 1888.

Hurd, D Hamilton, ed. *History of Essex County, Massachusetts.* Philadelphia, PA: J.W. Lewis & Co., 1888.

Pringle, James R. *History of the Town and City of Gloucester, Cape Ann, Massachusetts.* Gloucester, MA: self-published, 1892.

Rockport Granite Company Scrapbook. Sandy Bay Historical Society, 1960.

Wood, Paul. The Chronicles of the Early American Industries Association, Inc., Tools and Machinery, June, September 2006, March 2007.

ABOUT THE ORGANIZATIONS

There are three organizations on Cape Ann that have excellent granite exhibits for those interested in seeing and learning more about the subject, the Cape Ann Museum, the Sandy Bay Historical Society, and the Halibut Point State Park. The two museum exhibits have been staged with the assistance of granite expert Les Bartlett, an experienced, professional photographer who has spent many early mornings and late afternoons in the quarries taking fine art photographs of the rustic beauty that the quarries provide. His extensive study of the granite industry has informed his experiences about the people who worked the quarries.

The Cape Ann Museum on Pleasant Street in Gloucester has a granite-industry exhibit in their auditorium on the first floor and includes large panoramic photographs as well as many implements, ledgers, stone sloop models, and maps of the Cape Ann quarry system. The exhibit is well labeled and provides details of each tool and how they were used.

The Sandy Bay Historical Society Museum on King Street in Rockport has their exhibit on the lower level of the museum and also has large poster-sized photographs that highlight many of the workers and the quarries in which they were employed. There are also tools and many unique items all relevant to the granite industry.

Both museums have extensive libraries and archives where more information can be researched by serious researchers or just curious browsers. To learn more or become a member go to their websites at www.capeannmuseum.org or www.sandybayhistorical.org.

Halibut Point State Park is located on Gott Street in Rockport. It encompasses the four-acre old Babson Farm Quarry and offers the public an excellent experience at their visitors' center on the edge of the quarry. It features exhibits related to the park's natural and cultural history. They have a fine granite exhibit, films, and live demonstrations during the summer. Check their website for more information at www.halibutpoint.wordpress.com.

DISCOVER THOUSANDS OF LOCAL HISTORY BOOKS FEATURING MILLIONS OF VINTAGE IMAGES

Arcadia Publishing, the leading local history publisher in the United States, is committed to making history accessible and meaningful through publishing books that celebrate and preserve the heritage of America's people and places.

Find more books like this at
www.arcadiapublishing.com

Search for your hometown history, your old stomping grounds, and even your favorite sports team.